IMAGES
of America

PHILADELPHIA'S RITTENHOUSE SQUARE

Dear Marty

Never had a chance
to pay ADIOS, AU VOIR ^RE

AUFWIEDERS EHEN , ARRIVEDERCI

Your's Truly

George M. Goff

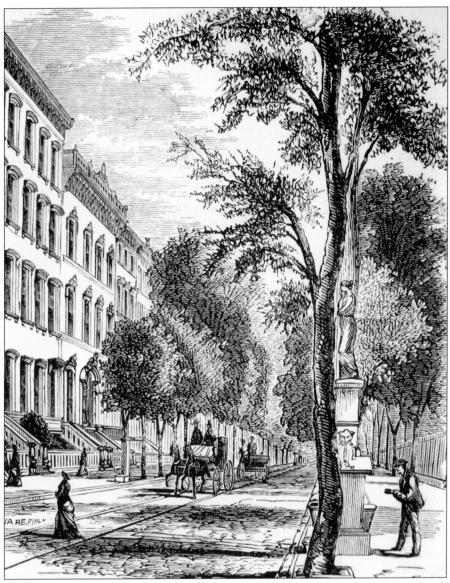

By the time of the 1876 Philadelphia Centennial Exhibition, Rittenhouse Square was already home to an elite society that lived in stately brownstone mansions surrounding the square. The park was fenced in at that time, and fountains on the streets, such as the one seen above, provided water for the horses that pulled the carriages of local residents. The trolley tracks on Walnut Street were for the horse-drawn trolley lines that connected the square with the old Colonial city to the east. (Free Library of Philadelphia.)

On the cover: In the mid-19th century, American engineer Joseph Harrison Jr. built a railroad from St. Petersburg to Moscow for the Czar of Russia. Returning to Philadelphia a wealthy man, Harrison purchased almost the entire block facing East Rittenhouse Square on Eighteenth Street from Walnut to Locust Streets. In 1852, he hired architect Samuel Sloan to design this unique house, modeled after a palace in St. Petersburg that his wife Sarah Harrison fancied. The Parc Rittenhouse stands on the site today. (Free Library of Philadelphia.)

IMAGES
of America

PHILADELPHIA'S RITTENHOUSE SQUARE

Robert Morris Skaler
and Thomas H. Keels

ARCADIA
PUBLISHING

Published by Arcadia Publishing
Charleston SC, Chicago IL, Portsmouth NH, San Francisco CA

Printed in the United States of America

Library of Congress Catalog Card Number: 2007937778

For all general information contact Arcadia Publishing at:
Telephone 843-853-2070
Fax 843-853-0044
E-mail sales@arcadiapublishing.com
For customer service and orders:
Toll-Free 1-888-313-2665

Visit us on the Internet at www.arcadiapublishing.com

CONTENTS

ACKNOWLEDGMENTS

Books like *Philadelphia's Rittenhouse Square* would not be possible without the wealth of public and private archival collections in Philadelphia and the dedicated and helpful people who make them accessible to the public.

Special thanks are owed to Karen Lightner and Geraldine Duclow of the Free Library of Philadelphia, who helped us discover so many images for this book. Special thanks must also go to William J. Jenoves, who did the archival photography, and to Lawrence M. Arrigale, for his editing and photographic expertise.

We must also thank the following institutions and associated individuals for their contributions: Melissa Caldwell and Gay Walling of the Philadelphia Art Alliance; Bruce Laverty and Michael Seneca of the Athenaeum of Philadelphia; Elizabeth Jarvis and Tina Gravatt of the Chestnut Hill Historical Society; Peter J. Ryker and Mary-Louise Fleisher of the Church of the Holy Trinity; Sally Branca and Susannah Thurlow of the Curtis Institute of Music; Jean Bradley of the Ethical Society of Philadelphia; Norman Fouhy and Ann Slater of the First Unitarian Church of Philadelphia; Trudy and Lewis Keen of the Fort Washington Historical Society; David Rowland, president of the Old York Road Historical Society; the Print Club of Philadelphia; Ed Noll of the Racquet Club of Philadelphia; Karen Schoenewaldt of the Rosenbach Museum and Library; Bob Hadfield of St. Mark's Episcopal Church; Fr. Daniel Mackle and Deacon Bill Mays of St. Patrick's Roman Catholic Church; David S. Traub of Save Our Sites; Charles and Ed Zwicker of the Springfield Township Historical Society; Temple Beth Zion–Beth Israel; Dot Boersma of the Tenth Presbyterian Church; James Mundy of the Union League of Philadelphia; and Brenda Galloway-Wright of the Urban Archives of Temple University.

We are especially indebted to the individuals who shared their private collections and expertise with us, particularly Andrew Herman, James Hill Jr., S. Hamill Horne, Gersil Kay, and Cintra and Wayne Willcox.

We also wish to thank the following businesses for providing images and information for this book: Robert Thomas of Campbell Thomas and Company; James N. Kise of Kise, Straw and Kolodner; Katie Cipolla of KlingStubbins; Katherine Mendez of the Radisson Plaza–Warwick Hotel; Diana M. Cammarota of the *Rittenhouse Sq. Revue*; and the staffs of the Rittenhouse Hotel, Schwarz Gallery, and Ten Rittenhouse Condominium.

Finally, we must express our gratitude to the late historian Charles J. Cohen, whose 1922 book *Rittenhouse Square Past and Present* was an invaluable source of information.

Unless otherwise noted, images are from the authors' collections.

INTRODUCTION

Rittenhouse Square, one of William Penn's original five public squares laid out in 1682 by Thomas Holme, was known as the South-West Square until 1825 when it was renamed for David Rittenhouse (1732–1796), an astronomer, clockmaker, scientist, founding father, and one of the amazing Renaissance men who seemed to fill 18th-century Philadelphia.

At first an undeveloped pasture surrounded by brickyards, Rittenhouse Square began to change in 1848 when Philip Syng Physick built the first house facing the square. Although his home was known as "Physick's Folly" for being so far out of town, Physick soon had neighbors as Philadelphians moved westward, escaping the commercial development and poor immigrants that had overwhelmed Old City and Society Hill. For the next century, Philadelphia's upper classes made Rittenhouse Square their enclave. The city's best-known architects, including John Notman and Frank Furness, designed the elegant residences, churches, and clubs surrounding Rittenhouse Square.

The brownstone and marble mansions on the square itself were inhabited by the city's wealthiest and most prestigious families. During its "high noon" from roughly 1876 to 1929, Rittenhouse Square inhabitants included Alexander Cassatt, president of the Pennsylvania Railroad; William Weightman, Philadelphia's largest real estate owner; John Wanamaker, founder of a great department store chain; financier and philanthropist Anthony Drexel; Edward T. Stotesbury, senior partner in Drexel, Morgan, and one of the wealthiest and most influential men in America; U.S. senator George Wharton Pepper; artist Rudolf Serkin; and Philadelphia Orchestra conductor Leopold Stokowski, to name a few.

Like other wealthy enclaves, Rittenhouse Square also sheltered its fair share of scandals. John Kearsley Mitchell, rubber tycoon and Stotesbury's son-in-law, led a dignified life on East Rittenhouse Square until his mistress, Broadway chorine Dot King, was found murdered in their New York love nest. Although Mitchell was quickly cleared of the murder, Dot King's nickname for her Philadelphia paramour soon became a popular slang term: "Sugar Daddy."

In 1913, French-born architect Paul Philippe Cret redesigned the square after the Parc Monceau in Paris, adding classical entrances and a central plaza with stone railings, pool, and fountain. By this time, however, many of Philadelphia's socially elite were leaving the city for suburban estates in Chestnut Hill or on the Main Line. In 1912–1913, the first high-rise apartment house was built on Rittenhouse Square, soon to be followed by several art deco towers during the 1920s.

As Rittenhouse Square residents fled to the suburbs, the few mansions that were not replaced by skyscrapers were taken over by cultural institutions like the Philadelphia Art Alliance and the Curtis Institute of Music. Many smaller residences or stables on surrounding streets were

purchased by private clubs, or redeveloped by suburbanites who needed a pied-à-terre for after the Assembly Ball or an orchestra concert. During the Depression, several formerly grand mansions were boarded up and abandoned, or demolished; the Weightman mansion at Eighteenth and Walnut Streets was torn down in 1929, and its empty site was used as a parking lot for the next 20 years.

After World War II, Rittenhouse Square began a slow renaissance, with the founding of community groups and the development of modern apartment and office buildings on and around the square. This rebirth has gained steam with the booming real estate market of recent years; as of year-end 2007, two new luxury condominium towers are underway at the square's northeast and northwest corners, while several older buildings have been redeveloped as condominiums.

Today while only a few original buildings survive, Rittenhouse Square remains Philadelphia's favorite urban park and one of its most fashionable residential districts. The surrounding streets are full of beautiful 19th-century and early-20th-century buildings, covering every style from Italianate to art deco, making the district one of Philadelphia's architectural showcases. Each year, the square hosts a popular art exhibit, flower show, and charity ball, all of which have become Philadelphia traditions. The area is still home to the world-famous Curtis Institute of Music and the Philadelphia Art Alliance and has numerous residences, clubs, and houses of worship designed by Philadelphia's leading architects.

Despite the many changes it has endured, Rittenhouse Square remains just as Jane Jacobs described it in 1961: "A beloved, successful, much-used park, one of Philadelphia's greatest assets." It was recently named one of the top 10 public places in North America by the Project for Public Spaces, which described it by saying, "There is a sense of community here, an interaction between the habitués of the park that makes one actually feel that this is the City of Brotherly Love after all. People recognize each other and life here has a comfort and allure that has almost vanished everywhere else in the city and the country."

One

THE EARLY YEARS
1682–1865

In 1682, when William Penn asked his surveyor Thomas Holme to draw up a city plan, it included five open squares that reflected Penn's desire for a "greene country towne." There was one large square in the center, where Philadelphia City Hall stands today, and four others at each corner of the growing town. Fast-growing Philadelphia soon needed these breathing spaces: by 1774, it had become the second-largest English-speaking city in the world, after London.

Rittenhouse Square was originally called South-West Square due to its location in that part of the city. Unlike other city squares, it was never used as a burial ground, but was a place for pigs and cows to roam and a convenient dumping spot for "night soil."

By the late 1700s, the square was surrounded by brickyards because the area's clay terrain was better suited for kilns than for crops. In 1816, local residents raised funds to enclose the square with a fence.

The name of South-West Square was changed in 1825 to honor David Rittenhouse (1732–1796). This amazing man of universal talents was a descendant of William Rittenhouse, who built the first paper mill in America in Germantown. David was at various times a member of the Pennsylvania General Assembly and the Pennsylvania Constitutional Convention, and president of the Council of Safety. Professor of astronomy at the University of Pennsylvania and inventor of the collimating telescope, he was also president of the American Philosophical Society and the first director of the United States Mint.

Over the next several decades, trees and walkways were added as the first large houses facing the square were built. In late 1859, the Philadelphia City Passenger Railway began to run horse-drawn trolley cars west on Chestnut Street from Front Street to a depot at Twenty-first and Chestnut Streets, and then back on Walnut Street. The horse trolley lines made it convenient for the city's social elite to move their homes from near their places of business in Society Hill, a Colonial neighborhood that had become a dense commercial district, to residential Rittenhouse Square. The square quickly became the most fashionable address for the city's upper classes, who made it their enclave for the next century. After the Civil War, the area around Rittenhouse Square was also built up with impressive churches, large single homes, and elegant row houses.

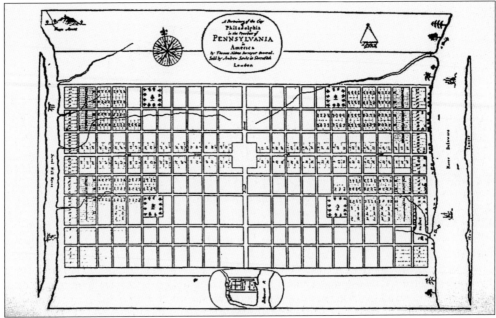

Thomas Holme was appointed surveyor-general of Pennsylvania by William Penn. He arrived in Philadelphia in 1682 and made the plan seen above, which included five public squares. Centre Square (today the site of Philadelphia City Hall) contained 10 acres of land, while the other four squares had eight acres apiece. The South-West Square, now known as Rittenhouse Square, is in the lower left corner of the map. The area around the South-West Square remained largely undeveloped, with grazing fields and brick pits, for the next 150 years. (Free Library of Philadelphia.)

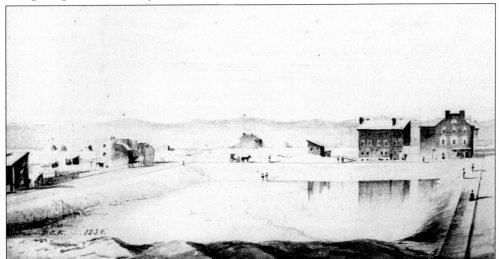

In 1839, David Kennedy sketched the South-West Square looking west from Nineteenth and Chestnut Streets. At Twentieth Street, milk was sold from cows pastured nearby, while chickens and pigs wandered around the south side of the square. The surrounding area had open clay pits, smoking brick kilns, and a few clusters of brick workers' shanties. At this time, the area west of Broad Street was starting to become a fashionable place for Philadelphia society to call home. The nondescript lot shown above would soon be transformed into elegant Rittenhouse Square. (Free Library of Philadelphia.)

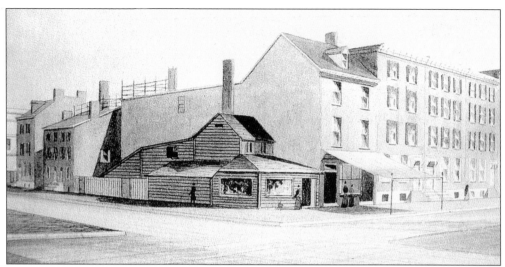

Chestnut Street around Fifteenth Street began to be built up around 1830 with plain brick-faced row houses befitting Philadelphia's Quaker modesty. These homes of the merchant middle class where still within walking distance of the old Colonial city, which by the mid-19th century had become Philadelphia's business and financial center. With the inauguration of horse trolley lines around 1860, the westward residential development would rapidly increase and surge toward Rittenhouse Square. (Free Library of Philadelphia.)

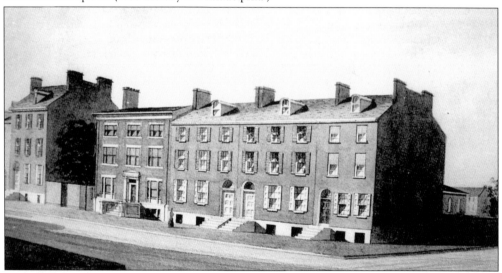

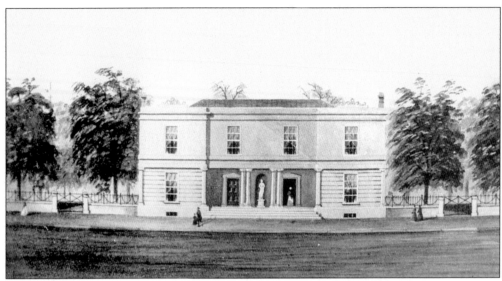

As Society Hill grew more commercial in the 1830s and 1840s, affluent Philadelphians began to build their homes west of Broad Street. One notable example was the home of merchant Charles Blight, built in 1836 on the southeast corner of Sixteenth and Chestnut Streets (above). It was designed with an impressive white marble facade by architect John Haviland, known for his Greek Revival designs. In 1828, the Blight brothers had Haviland design a planned residential development named Colonnade Row (below) in the same style on the south side of the 1500 block of Chestnut Street. (Free Library of Philadelphia.)

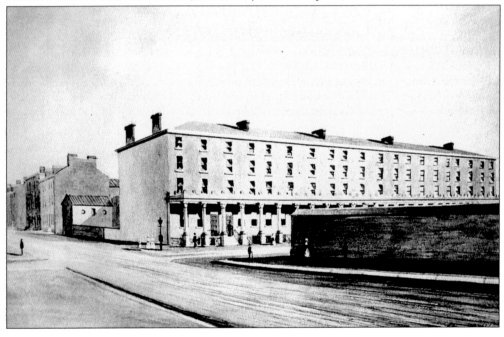

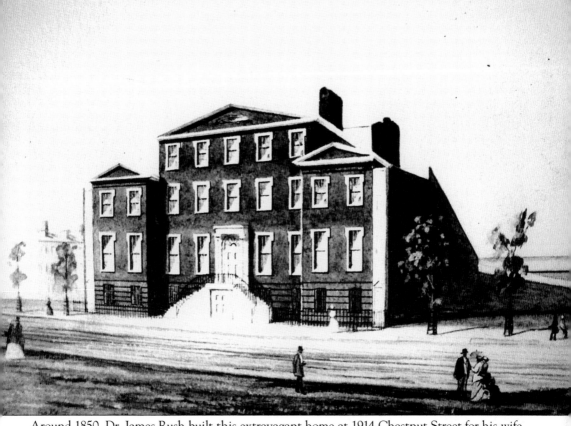

Around 1850, Dr. James Rush built this extravagant home at 1914 Chestnut Street for his wife, the former Phoebe Ann Ridgway, as seen in this David Kennedy watercolor. Phoebe was one of the richest women in the country and wanted an elegant salon in which to entertain as the reigning hostess in Philadelphia society. In 1887, the house was converted to the Aldine Hotel with the addition of several floors to the house's structure. (Free Library of Philadelphia.)

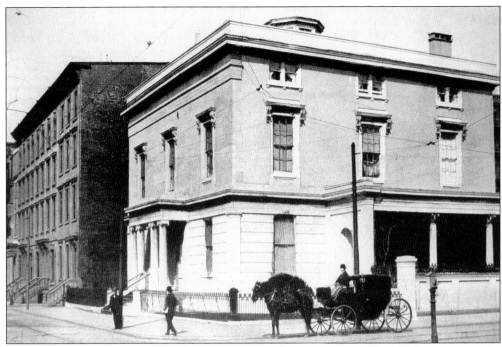

In 1848, another great house was built facing Rittenhouse Square at 1901 Walnut Street. The country home of Dr. Philip Syng Physick, seen here in 1902, was called "Physick's Folly" because at the time it was built its location was far outside of town. Designed by an unknown architect, this elegant white marble-and-stucco house had a three-story circular center hall illuminated by an octagonal cupola. After it was purchased in 1864 by Algernon Sydney Roberts, it became known as the Physick-Roberts House. Below, the Physick-Roberts House is seen at right in 1912. In 1925, the house was demolished for the Rittenhouse Plaza Apartments. (Free Library of Philadelphia.)

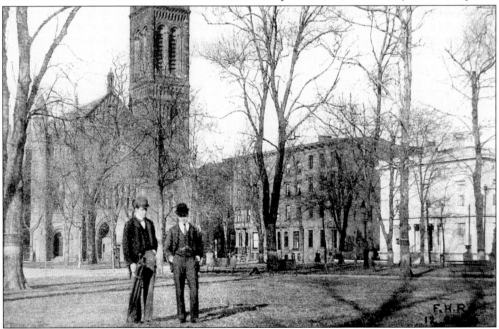

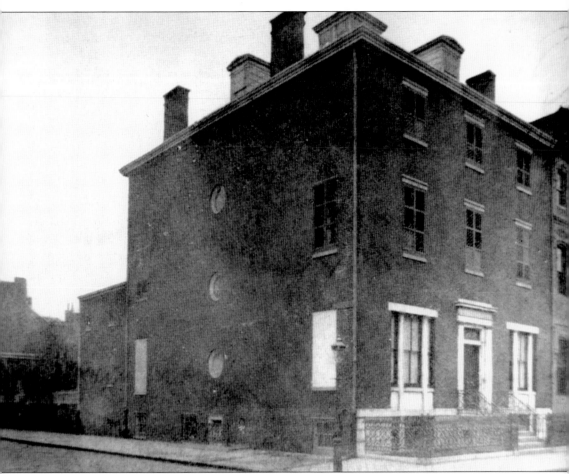

The southeast corner of Eighteenth and Locust Streets, today the location of the Curtis Institute of Music, was once the site of the residence of David Winebrenner, built around 1835. Historian Charles Cohen tells the story of when an antique crystal chandelier in the house was changed from candles to gaslight in the 1850s: "There was so much excitement among the neighbors when it became known that a test was to be made on a certain evening, at which time the neighbors flocked to Rittenhouse Square so as to be removed from danger of an explosion that the alarmist prophesied would certainly follow." In 1894, the house was demolished by George W. Childs Drexel who hired the Boston firm of Peabody and Stearns to design a new Beaux-Arts mansion, which was extended southward on Eighteenth Street in 1920. In 1924, the Curtis Institute of Music was established in the Drexel mansion by Mary Louise Curtis Bok.

One of the first large houses erected on Rittenhouse Square was the home of Congressman James Harper at 1811 Walnut Street. When first built in 1840, the Harper house was freestanding and surrounded by open fields. The house, shown here in 1901, had a unique white marble portico and soon became a local attraction. Harper, who had presided over the banquet given for General Lafayette when the latter visited Philadelphia in 1824, owned brickyards on the north side of Walnut between Eighteenth and Nineteenth Streets. When he tried to mechanize the manufacture of bricks in 1844, an angry mob of brick workers destroyed the machinery. He retired in 1848, and grew even wealthier when land he had bought for $1 per square foot years before was sold for $20 a square foot. In 1878, the Harper house became the Social Art Club, later known as the Rittenhouse Club. (Free Library of Philadelphia.)

By the 1860s, Walnut Street looking west from Seventeenth Street toward Rittenhouse Square was lined with the stately brownstone mansions of Philadelphia society. The tower of the Church of the Holy Trinity at Nineteenth Street can be seen in the distance. (Free Library of Philadelphia.)

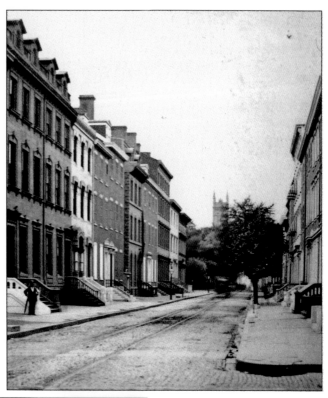

Walnut Street at Nineteenth Street had rows of brownstones with high New York–style stoops across from Holy Trinity. The fence of the Physick-Roberts mansion can be seen in the foreground. The newly formed horse-drawn trolley lines made it convenient for the owners of these grand houses to travel to their places of business in the old Colonial section of the city, now Philadelphia's main banking and commercial district. (Free Library of Philadelphia.)

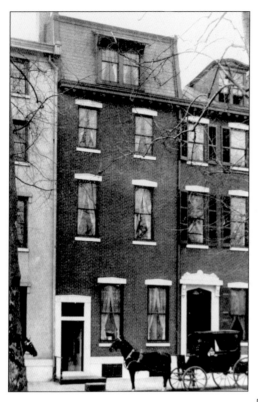

Built in 1850 for a Mrs. Griffith, this modest home at 1808 South Rittenhouse Square was occupied for a short time by the former Mrs. Pierce Butler, better known as the English actress Fanny Kemble. Kemble married Butler in 1834, but divorced him after they moved from Philadelphia to his huge Georgia plantation. Kemble's strong antislavery views created "irreconcilable differences" in her marriage to the slave-owning Butler; their 1849 divorce created a huge scandal in staid Philadelphia. In 1881, Edward T. Dobbins, a member of John J. Wyeth and Sons manufacturing chemists, purchased the house.

When Fanny Kemble lived on Rittenhouse Square, she was a breath of fresh air to staid Philadelphia society. She was well-educated and a friend of the great artists of her day, like Franz Liszt and Henry James. Her daughter Sarah fell in love with a Quaker doctor, Owen Wister. Sarah and Owen had one child, Owen Wister Jr., the popular novelist and author of the 1902 western classic *The Virginian*. Besides her home on the square, Fanny Kemble would sometimes stay in a small cottage at Butler Place, the Wister country estate formerly owned by her ex-husband Pierce Butler, in the Germantown section of Philadelphia.

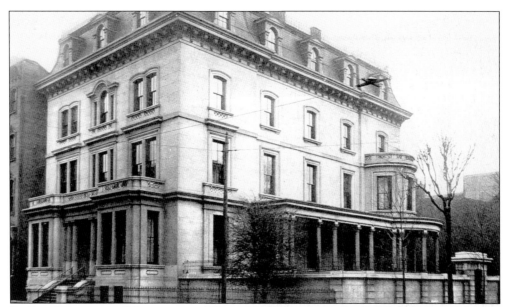

Dr. David Jayne was well-known around the world for his patent medicines. He was also well-known in Philadelphia for the imposing Jayne Building, at 242–244 Chestnut Street, at 10 stories the country's first prototype skyscraper. In 1865, Dr. Jayne had architect John McArthur Jr. design this mansard-roofed Second Empire mansion at the southeast corner of Nineteenth and Chestnut Streets. The unique white marble mansion stood out among the brick and brownstone homes of the area. It was demolished in 1921 for the construction of the Aldine Theater.

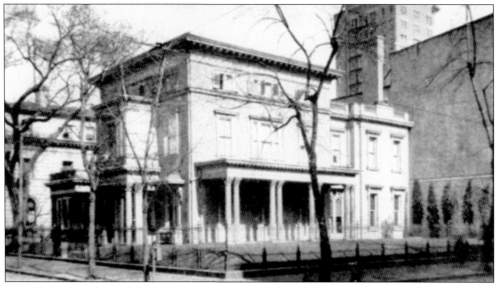

This elegant Italianate villa was originally built in 1858 for John Edgar Thomson on the northeast corner of Eighteenth and Spruce Streets. Thomson was one of several presidents of the Pennsylvania Railroad who lived on Rittenhouse Square. In 1871, Thomson bought the vacant lot north of his house and announced plans to build a home for orphans of railroad men. Partly because of his neighbors' protests, the orphans' home was never built. Instead, the lot was sold to Samuel Price Wetherill who built his mansion, seen in the background, on the site in 1906. This view shows the house in 1912.

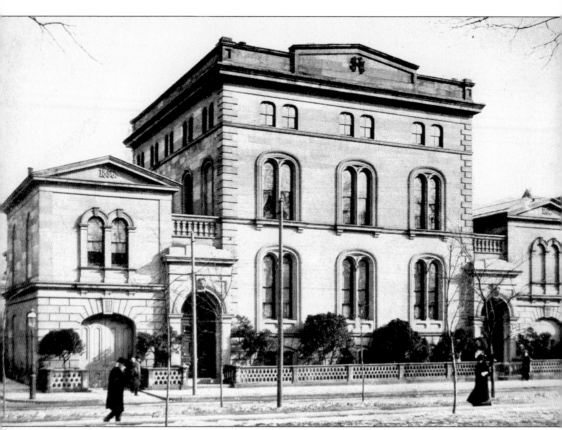

In the mid-19th century, engineer Joseph Harrison Jr. built a railroad from St. Petersburg to Moscow for the Czar of Russia. This Herculean task took five years, and when it was finished, Harrison had to bring suit in the Supreme Court of Russia to be paid. He won and returned to Philadelphia a very wealthy man. He purchased most of the block facing East Rittenhouse Square on Eighteenth Street from Walnut to Locust Streets. In 1852, he hired architect Samuel Sloan to design this unique house modeled after a St. Petersburg palace that his wife Sarah Harrison admired. The Harrison mansion, with its octagonal greenhouse and domed art gallery, established Rittenhouse Square as the city's most prestigious neighborhood. After Harrison's widow died in 1912, Edward T. Stotesbury purchased the Harrison property. Stotesbury never lived there, but loaned the house to the Emergency Aid Committee of Philadelphia during World War I. In 1923, the mansion was demolished for construction of the Penn Athletic Club. (Free Library of Philadelphia.)

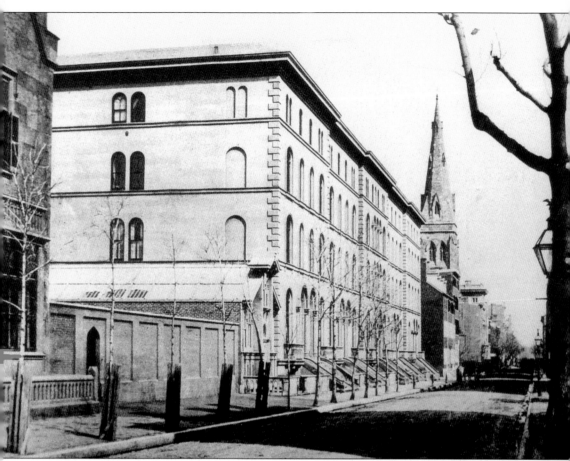

The 19th-century character of Locust Street was established by St. Mark's Episcopal Church and the great Italianate brownstone houses that were built on the 1600 block of Locust Street. In 1856, Harrison Row, a row of 10 houses, above, was designed by architect Samuel Sloan for Joseph Harrison Jr., who rented them to a select clientele. The houses shared a formal community garden with the Harrison Mansion that faced Rittenhouse Square. Many of the c. 1850 houses on the south side of the 1600 block of Locust Street were designed in the Italianate style by John Notman, the architect of St. Mark's church. (Free Library of Philadelphia.)

In 1863, Theodore Cuyler, prominent lawyer and first president of the Rittenhouse Club, purchased the house at 1826 South Rittenhouse Square. In 1870, Cuyler had the architectural firm of Fraser, Furness and Hewitt renovate the property, enlarging it to include 1824, and unifying the two properties with a gray stone facade. Robert Miller Janney, banker and ex-president of the Philadelphia Stock Exchange, purchased the house in 1898. In 1899, architect Theophilus P. Chandler renovated the house's front entrance as seen in this 1902 photograph.

Two

THE GILDED AGE
1866–1912

After the Civil War, Rittenhouse Square became Philadelphia's most fashionable district, home to more millionaires per square foot than any other area of the city. The original, comparatively modest houses and speculative buildings gave way to luxurious townhouses designed by Frank Furness, Horace Trumbauer, Theophilus P. Chandler, and other famous architects. Consequently, the area around Rittenhouse Square was fully developed by 1910, with Philadelphia's elite living around the square in close proximity to their back-street stables and servants' quarters. By 1900, Rittenhouse Square had become synonymous with Upper Fifth Avenue in New York and Back Bay Boston as an upper-class urban enclave.

In the late 19th century, members of Philadelphia high society were expected to live south of Market Street between Chestnut and Pine Streets. Many prominent Philadelphians—self-made industrialists and merchants like Widener, Elkins, Foederer, Gimbel, Snellenberg, and Disston—resided "north of Market" in the great mansions that lined North Broad Street. While these men were as wealthy, or wealthier, than those who lived around Rittenhouse Square, a North Broad Street address could never have the cachet of one "on the Square." A sedate Rittenhouse Square brownstone conferred the status of "Old Philadelphia" on those who lived there, even if they had made their money in the last generation. Conversely, those who lived on North Broad Street were considered nouveau riche, with their grandiose mansions built on a much larger and grander scale than those "south of Market."

In the early 20th century, a combination of factors led to the gradual decline of Rittenhouse Square: improved transportation that allowed affluent Philadelphians to commute easily from Chestnut Hill or the Main Line to Center City, the introduction of an income tax that made it difficult for the wealthy to afford large mansions, and increasing congestion and rising land values on the square itself. In 1912, one of the square's grandest mansions was demolished for a high-rise apartment building—a harbinger of the many changes that Rittenhouse Square would endure over the next century.

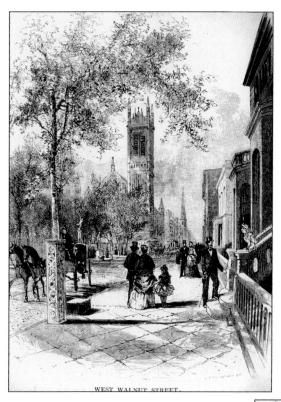

WEST WALNUT STREET.

By the time this engraving appeared in 1876, Rittenhouse Square had emerged as Philadelphia's most affluent and fashionable neighborhood. Walnut Street, seen here looking west from Eighteenth Street, was lined with brownstone and marble mansions, and decorated with elaborate fountains and ornamental tree guards. At the center of the engraving rises the tower of the Church of the Holy Trinity, which had anchored the northwest corner of the square since 1859. (Free Library of Philadelphia.)

Rittenhouse Square was enclosed with an iron railing in 1853. The entire square was used as a drilling ground during the Civil War, and it remained without improvements for many years. In 1872, this cast iron fountain—grand in scale, tall, and "grotesque"—was installed near Walnut and Rittenhouse Streets, a gift of an anonymous lady to the Philadelphia Fountain Society. A second fountain was given by J. Gillingham Fell, one of the founders of the Union League of Philadelphia. Unfortunately, because their uncontrolled sprays made the ground sodden, these fountains became unpopular and were removed. (Free Library of Philadelphia.)

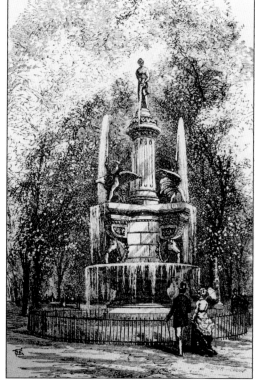

Thomas Alexander Scott had his luxurious home at the southeast corner of Nineteenth Street and Rittenhouse Square. Scott was the president of the Pennsylvania Railroad for six years during its heyday as the largest and wealthiest American corporation. His house was designed by the architectural firm of Furness and Hewitt in 1875 and was expanded to 52 rooms in 1887–1888. Frank Furness's signature architectural motif, elaborate and massive brick chimneys, is prominently displayed in this house's design. It was demolished in 1912 to build the first high-rise apartment house on the square.

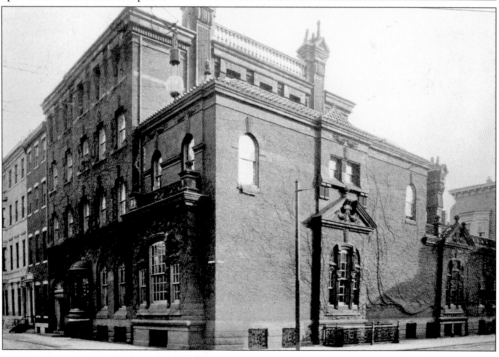

Alexander Cassatt, president of the Pennsylvania Railroad, was a visionary who sought a better way besides ferries to bring the Railroad's millions of passengers from New Jersey into Manhattan. Cassatt embarked on an ambitious idea of constructing train tunnels under the Hudson River, leading to a new Penn Station, which was denounced as "corporate folly." His sister, Mary Cassatt, was a famous expatriate painter.

Alexander Cassatt's wife, Lois (Buchanan) Cassatt, was the niece of Pres. James Buchanan and one of the leaders of Philadelphia Society. A patroness of the arts, music, and languages, she also served as president of the Alliance Française.

In 1856, Fairman Rogers built his house at 202 South Nineteenth Street, next to the Church of the Holy Trinity. Rogers, who served with the First City Troop during the Civil War, was a founder of the Academy of Natural History, a director of the Pennsylvania Academy of the Fine Arts, and an early member of the Union League. The property was sold in 1888 to Alexander Cassatt, president of the Pennsylvania Railroad. Cassatt had architect Frank Furness, who did many projects for the Pennsylvania Railroad, renovate the house.

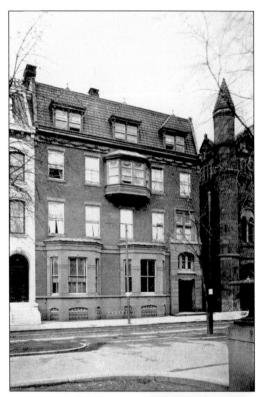

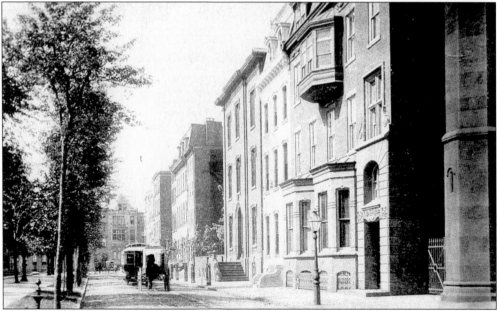

This view shows the west side of Rittenhouse Square in the 1890s. The Alexander Cassatt house in the foreground became the church house for the Episcopal Diocese of Pennsylvania in 1922. It was demolished in 1972 for the construction of the Rittenhouse Hotel. Ironically, the hotel has a tearoom named after Alexander's sister, famous artist Mary Cassatt, who visited but never lived in the Andrew Cassatt house.

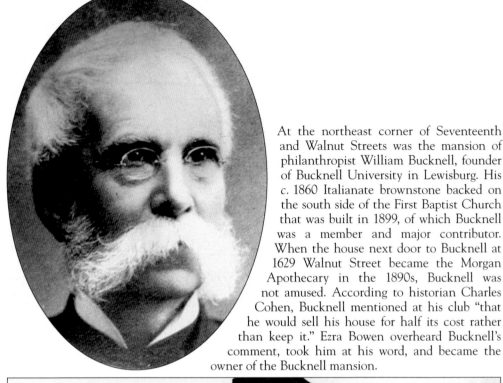

At the northeast corner of Seventeenth and Walnut Streets was the mansion of philanthropist William Bucknell, founder of Bucknell University in Lewisburg. His *c.* 1860 Italianate brownstone backed on the south side of the First Baptist Church that was built in 1899, of which Bucknell was a member and major contributor. When the house next door to Bucknell at 1629 Walnut Street became the Morgan Apothecary in the 1890s, Bucknell was not amused. According to historian Charles Cohen, Bucknell mentioned at his club "that he would sell his house for half its cost rather than keep it." Ezra Bowen overheard Bucknell's comment, took him at his word, and became the owner of the Bucknell mansion.

Capt. William West Frazier was a Civil War compatriot of architect Frank Furness, having served with him in the Rush's Lancers. Frazier made his fortune in sugar refining and was a director of many charitable institutions. In 1881, he had the firm of Furness and Evans design his residence on the prominent southwest corner of Eighteenth Street and Rittenhouse Square (below). The house's striking design secured many other clients for Furness and Evans in the Rittenhouse Square area. Frazier also gave many more architectural commissions to Furness. A high-rise apartment house built in the 1920s occupies the site today.

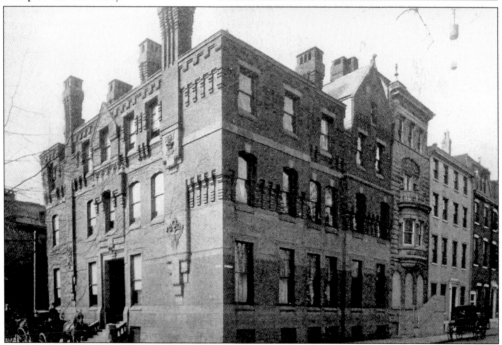

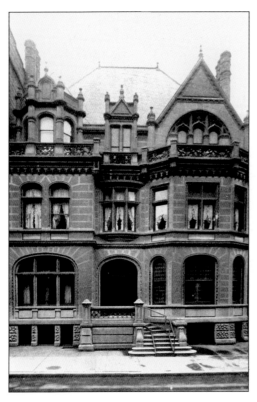

The townhouse of Hon. John Wanamaker at 2032 Walnut Street was originally built in 1882 for James Scott. Its architect, Theophilus P. Chandler, designed it in the high Victorian French chateau style popular at the time. Wanamaker, founder of the Wanamaker Department store chain, was Philadelphia's most prominent merchant and a great philanthropist. In 1928, the house was converted into apartments; in 1978, it was badly damaged in a fire. Only the historical facade remains today as part of a luxury condominium high-rise called the Wanamaker House.

Still standing at 125 South Twenty-second Street is the home of Hon. John C. Bullitt, originally designed for Thomas Cochrane in 1882 by architects G. W. and W. D. Hewitt. Bullitt was a prominent Philadelphia lawyer and director of numerous banks and insurance companies. The Hewitt brothers also designed the massive Bullitt Building at 131–145 South Fourth Street in Society Hill that incorporated many of the same heavy architectural elements as the Richardsonian Romanesque–style Bullitt mansion.

The elegant mansion (below) located at the northeast corner of Eighteenth and Walnut Streets was originally built around 1876 for William Wilstach. In 1893, the house was purchased by financier Anthony Drexel Jr., a well-known yachtsman and clubman, whose numerous relatives owned many other large mansions on or near Rittenhouse Square. Drexel hired architect Wilson Eyre Jr. to design a two-story domed conservatory on the back of the house. To further establish himself into the elite society ensconced around the square, Anthony Drexel Jr. followed his father in converting from Catholicism to become an Episcopalian. The house later belonged to financier William Warren Gibbs.

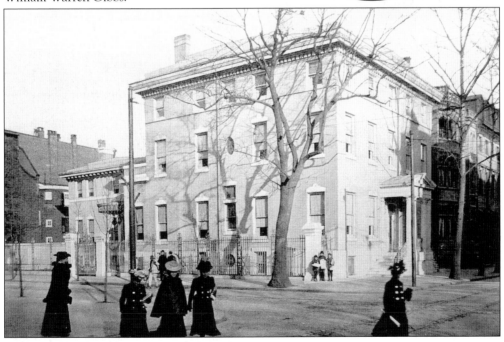

William Weightman, chemical manufacturer and real estate magnate, was born in Waltham, Lincolnshire, on September 30, 1813. He emigrated to the United States at the age of 16 in 1829 on the suggestion of his uncle, chemist John Farr, founder of Farr and Kunzi, the first manufacturers of sulfate of quinine in America. In 1847, the business became Powers and Weightman, chemical manufacturers. Weightman amassed a large fortune from his manufacturing endeavors and shrewd real estate investments. When Weightman died in 1904 at age 91, his fortune was estimated at $56 million ($44 billion in today's dollars). Weightman's granite and stone mansion, located at the southeast corner of Eighteenth and Walnut Streets, is seen below as it was in 1902.

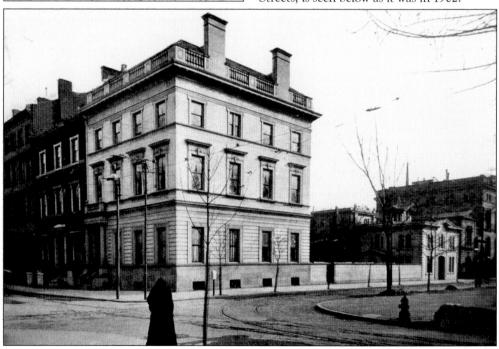

When it opened in 1887, the Aldine Hotel was built on the site of the old Rush-Ridgway mansion (at left), which was enlarged and incorporated into the hotel. At that time, the Aldine Hotel was one of Philadelphia's most fashionable addresses. Located at 1910–1922 Chestnut Street, it was designed for the Estate of L. B. Lippincott by architects Yarnall and Cooper and expanded in 1895 with a new addition by architect Addison Hutton. In 1899, when the average worker's wages were about $1 a day, the Aldine advertised its daily room rates as $3.50 to $5, with private baths and parlor extra.

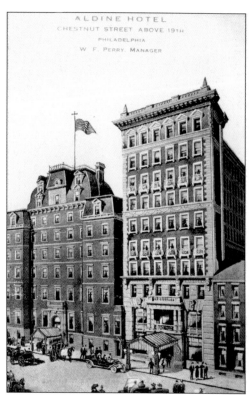

The Rittenhouse Hotel and Apartments in the 2100 block of Chestnut Street were designed in the Queen Anne style by architect Angus Wade in 1893 for developer John Sharp. Wade specialized in hotels, designing the Walton, Bingham, and Hanover in Philadelphia, none of which are standing today. A modern medical center now occupies the site of the Rittenhouse Hotel. On the corner of Twenty-first Street can be seen the Bradsbury Bedell house designed in 1889 by Wilson Eyre. Sadly, its first floor was made into a drug store in the 1960s.

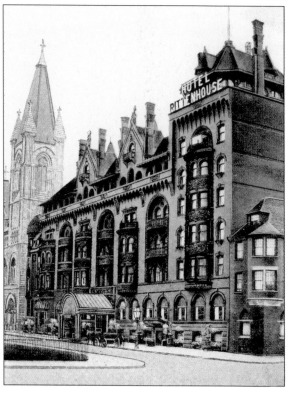

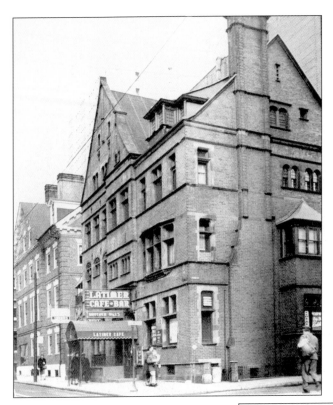

Edward Wood had architect Frank Miles Day design this huge double house at Seventeenth and Latimer Streets in 1888, shortly after Day had won the competition for the Philadelphia Art Club at 220 South Broad Street. By 1901, when the James Markoe house in the background was built, the Georgian Revival style had replaced Day's picturesque Queen Anne style. By 1953, at a time when many large Center City houses were being converted into restaurants, clubs, and bars, the Wood house had become the Latimer Café Bar. The building has since been restored and now houses the Black Sheep Bar. (Free Library of Philadelphia.)

At 1526 Walnut Street was the unique home of William P. Ellison, designed in the Queen Anne style (characterized at the time as a "dainty modern style") by architect Frank Miles Day around 1888. The firm of John Ellison and Sons, established in 1823, exported and imported wool products. To the left was the home of Dr. S. Weir Mitchell, designed by architect Louis Baker Jr. When this photograph was made in 1902, the 1500 block of Walnut Street was still a fashionable residential area.

In 1890, Wilson Eyre Jr. designed this double house at 315–317 South Twenty-second Street, known as the Neil and Mauran houses, as a development for real estate agent John Neil. Eyre combined Colonial and medieval elements in this unique Queen Anne–style design, placing both houses under a large gambrel roof to make it look like one structure. He lavished attention on the limestone entrance to the houses, separating them with a carved medieval figure. (Free Library of Philadelphia.)

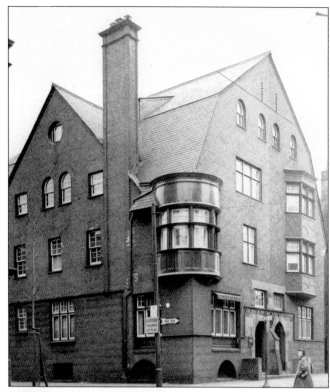

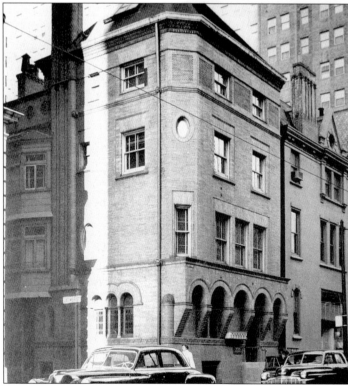

Another unique Wilson Eyre Jr. house is 242 South Seventeenth Street designed in 1895. Here Eyre used Pompeian brick corbels to add space to the house, which sat on a very shallow lot. (Free Library of Philadelphia.)

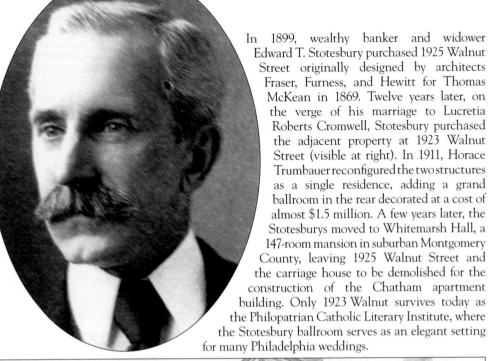

In 1899, wealthy banker and widower Edward T. Stotesbury purchased 1925 Walnut Street originally designed by architects Fraser, Furness, and Hewitt for Thomas McKean in 1869. Twelve years later, on the verge of his marriage to Lucretia Roberts Cromwell, Stotesbury purchased the adjacent property at 1923 Walnut Street (visible at right). In 1911, Horace Trumbauer reconfigured the two structures as a single residence, adding a grand ballroom in the rear decorated at a cost of almost $1.5 million. A few years later, the Stotesburys moved to Whitemarsh Hall, a 147-room mansion in suburban Montgomery County, leaving 1925 Walnut Street and the carriage house to be demolished for the construction of the Chatham apartment building. Only 1923 Walnut survives today as the Philopatrian Catholic Literary Institute, where the Stotesbury ballroom serves as an elegant setting for many Philadelphia weddings.

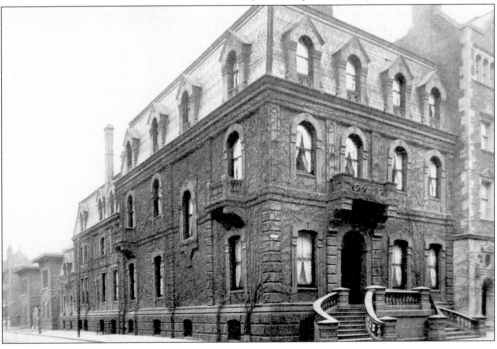

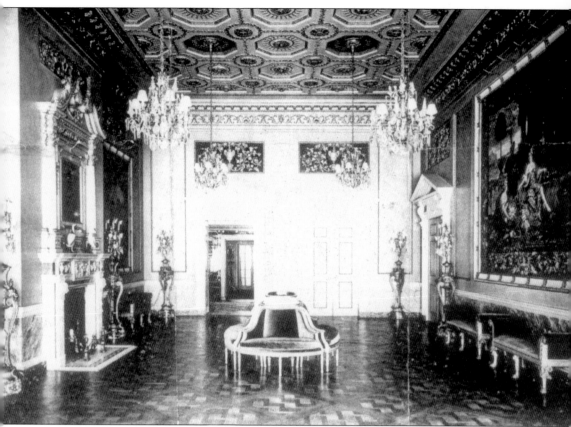

In 1911, Horace Trumbauer transformed Edward T. Stotesbury's home from the Victorian eclectic structure designed by Frank Furness in 1869 into an elegant Edwardian residence. Trumbauer, with the assistance of interior decorators Charles C. Allon and Lucien Alavoine, decorated this ballroom. Prestigious art dealer Joseph Duveen filed the room with art and antiques of the period. (Springfield Township Historical Society.)

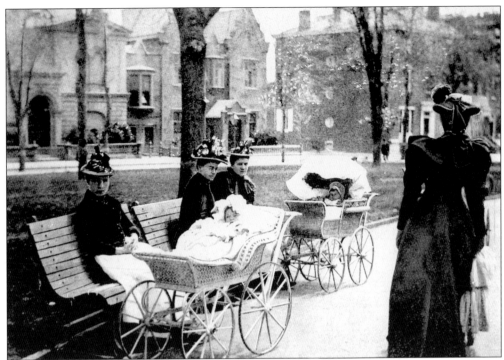

Nannies with prams parade the east side of Rittenhouse Square in the late 1880s, looking like extras from the British television series *Upstairs, Downstairs*. The square then closely resembled a private London gated park of the Victorian age, surrounded with large private homes and fenced in as seen below. (Free Library of Philadelphia.)

From 1849 to around 1895, William R. Lejee lived in this restrained Italianate house at the northwest corner of Eighteenth and Walnut Streets. Lejee was born in Switzerland and immigrated to America, becoming a successful banker and broker. When he died, the property was sold to John R. and Sarah Fell who tore down this modest house and built a huge Beaux-Arts mansion on the site. (Free Library of Philadelphia.)

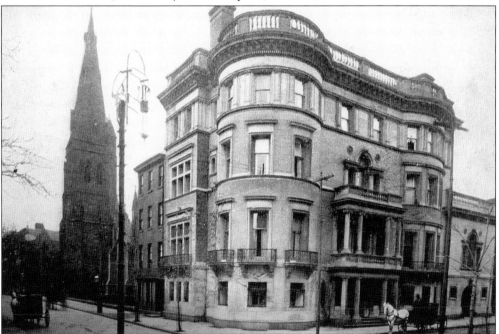

In 1895, architects Hazlehurst and Huckel designed this Beaux-Arts residence at the northwest corner of Sixteenth and Locust Streets for Daniel Baugh. The house's design with its rounded corner and double portico was uniquely different from Locust Street's staid Italianate brownstones, making it one the area's most notable residences. It was demolished in 1928 for the University Club.

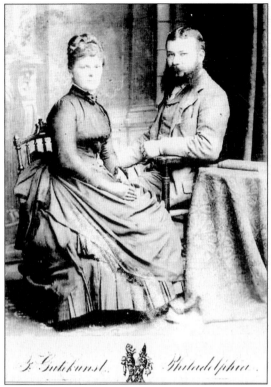

Sarah Drexel, youngest daughter of financier A. J. Drexel, is shown at left with her husband, John R. Fell, shortly after their marriage in 1879. Fell died in 1895 at the age of 37. Two years later, his widow spent $250,000 to build a splendid Beaux-Arts mansion, designed by the Boston firm of Peabody and Stearns at the northwest corner of Eighteenth and Walnut Streets (below). Its lavish interior featured a stained-glass dome over the main hall and the Doges' Room, where the ceiling was covered with medallion portraits of the popes. Shortly after the house was finished, Sarah Drexel Fell married Alexander Van Rensselaer; their mansion became known as the Fell–Van Rensselaer House. The Van Rensselaer family occupied the mansion until 1942. (Trudy and Lewis Keen.)

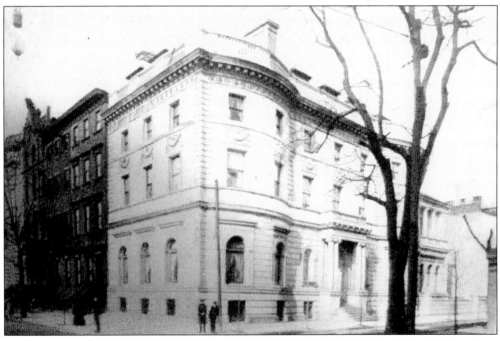

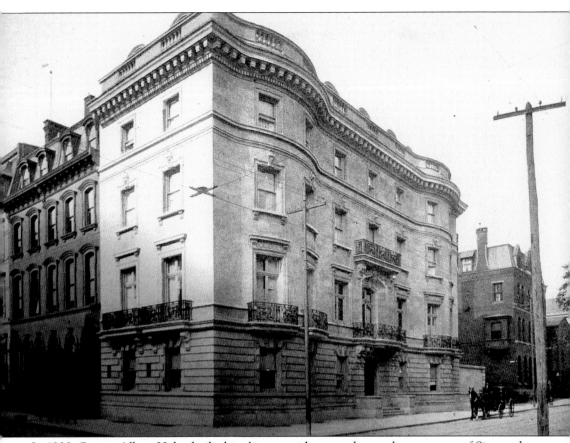

In 1900, George Albert Huhn built this elegant residence at the northwest corner of Sixteenth and Walnut Streets. Huhn, one of Philadelphia's leading stockbrokers and bankers, had Horace Trumbauer design this Beaux-Arts mansion, which closely resembles the Fell–Van Rensselaer mansion designed four years earlier by Peabody and Stearns. The house, estimated to cost $200,000, was built on the site of the former home of Dr. D. Hayes Agnew. Agnew was immortalized by Thomas Eakins in his 1889 painting *The Agnew Clinic*, commissioned by Agnew's University of Pennsylvania students to celebrate the physician's retirement as professor of surgery. In October 1915, the *Philadelphia Record* noted that the Huhn residence was to be demolished for a new professional office building.

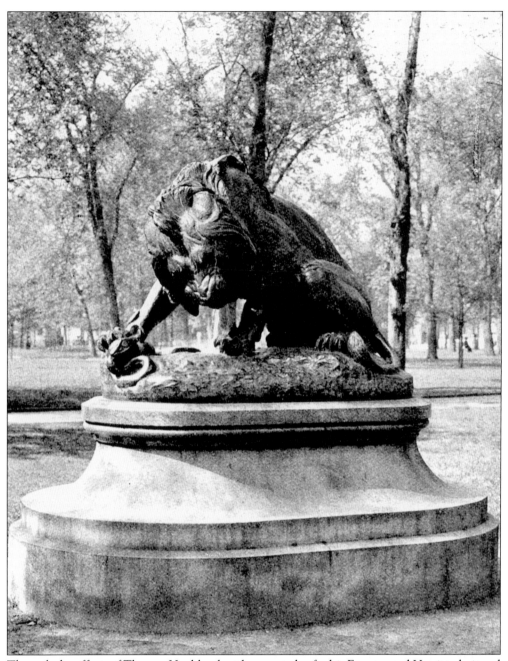

Through the efforts of Thomas Hockley, best known today for his Furness and Hewitt–designed home at 235 South Twenty-first Street, the Fairmount Park Art Commission was able to secure *Lion Crushing a Serpent* by Antoine Louis Barye and place it in the center of Rittenhouse Square in 1892. Barye was a teacher of Rodin and was known for his remarkable animal sculptures. He made this masterpiece in 1832. Another early acquisition to the square's fine collection of statuary was the 1911 *Duck Girl*, by Paul Manship, which was placed in the children's pool. (Free Library of Philadelphia.)

Jay Cooke III was the grandson of Civil War financier Jay Cooke. He was a banker, broker, and member of the New York and Philadelphia Stock Exchanges. This 1902 photograph of Jay Cooke III was taken for Moses King's *Philadelphia and Notable Philadelphians.* At a time when many of his business and social contemporaries wore mustaches or beards, Cooke was clean-shaven, denoting a dashing, modern nature.

Jay Cooke III had architect Albert Kelsey design this elegant Beaux-Arts mansion for him at 2128 Locust Street in 1900. Kelsey's design looks more like the townhouses being built on the Upper East Side of Manhattan at that time rather than the typically conservative Philadelphia Colonial Revival houses like the one next door.

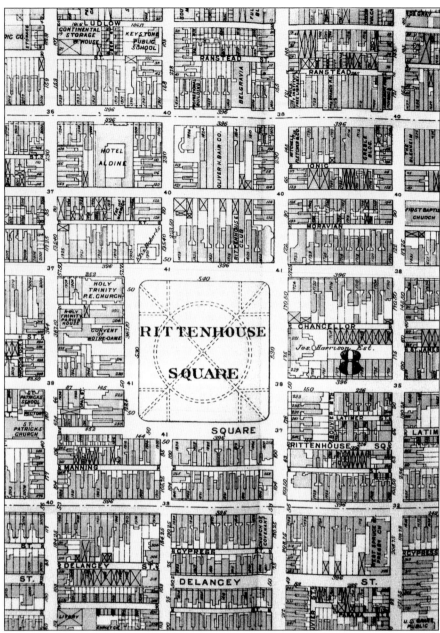

"Let every house be placed, if the person pleases, in the middle of its plat, as to the breadthway of it, so that there may be ground on each side for gardens or orchards, or fields, that it may be a greene country towne, which will never be burnt & always wholesome." These were William Penn's "Instructions to his Commissioners," William Crispin, John Bezar, and Nathaniel Allen, dated "30th of Sept., A. D. 1681." Nevertheless, as this map of the Rittenhouse Square area from the 1910 Bromley Atlas of Philadelphia shows, there is not one piece of open ground left around the square except for a few private gardens, showing how popular the square had become in the past century. Rittenhouse Square would not have existed without the vision of William Penn and his surveyor, Thomas Holme, who laid out five open squares in hopes of providing some greenery for the inhabitants of Penn's "greene country towne." (Old York Road Historical Society.)

Three

THE RELIGIOUS LIFE
RITTENHOUSE SQUARE CHURCHES

Churches have played a critical role in the development of Rittenhouse Square. The first church in the vicinity, St. Patrick's (1839), served as a center of community life when the isolated area was inhabited primarily by Irish Catholic laborers.

In the 1840s and 1850s, the establishment of St. Mark's Episcopal Church and Calvary Presbyterian Church spurred the development of upper Locust Street. When St. Mark's opened in 1849, there were few houses on Locust west of Sixteenth Street. Within 10 years, Locust Street was lined with residences from Broad Street to Rittenhouse Square. The erection of Holy Trinity Episcopal Church, at the corner of Walnut Street and West Rittenhouse Square in 1857–1859, promoted construction around the square itself. Soon other churches relocated to Rittenhouse Square, following their congregants' westward movement.

These elegant new churches symbolized the economic status and social aspirations of their parishioners. Of the 30 new Episcopal congregations formed in Philadelphia between 1840 and 1860, seven were within five blocks of Rittenhouse Square. The concentration of so many Episcopal churches in such a small area cemented the square's reputation as the epicenter of Philadelphia's white Anglo-Saxon Protestant culture. Lavish weddings at Holy Trinity and St. Mark's for members of the Biddle, Drexel, and other old Philadelphia families were prominently featured in the *New York Times* and *Washington Post* as well as local newspapers.

In the 20th century, many churches faltered as parishioners moved to the suburbs. Faced with dwindling congregations and endowments, they were unable to maintain their large, costly structures. Some churches were demolished, like St. James' Episcopal (today the site of a gas station), others updated their structures to reflect changing tastes, like the First Unitarian Church, still others narrowly escaped destruction, like Holy Trinity. As Rittenhouse Square grew more diverse, so did its houses of worship: in 1954, the Church of the Covenant was reborn as the synagogue for Congregation Beth Zion–Beth Israel.

As Rittenhouse Square has revived recently, its churches and synagogues have resumed their role as centers of cultural and community life. They host activities ranging from classical concerts, theater, and art exhibitions to day care centers, food cupboards, and 12-step programs. Many congregations have renovated their facilities, restoring them to their original glory. Today Rittenhouse Square's houses of worship are masterpieces of 19th-century architecture, freshly adapted to meet the needs of a 21st-century community.

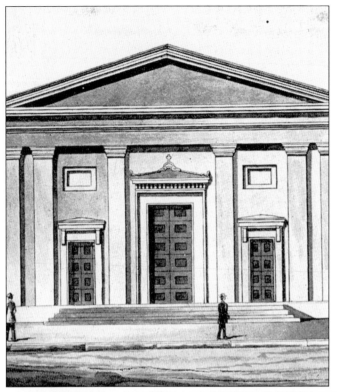

The Roman Catholic parish of St. Patrick's was established by Bishop Francis Kenrick in 1839 to serve Irish Catholic laborers in the city's southwestern quadrant. In 1841, Fr. Daniel Devitt purchased land at the northwest corner of Twentieth and Rittenhouse Streets for a new church to replace the converted factory that housed the parish. On that site rose a brick church designed by Napoleon LeBrun, which was later stuccoed and given a Greek Revival facade (left). The main altar of the church (seen below around 1905) held a glass-front casket containing the relics of St. Bonifacius, an early Christian martyr. (Left, St. Patrick's Church; below, Andrew Herman.)

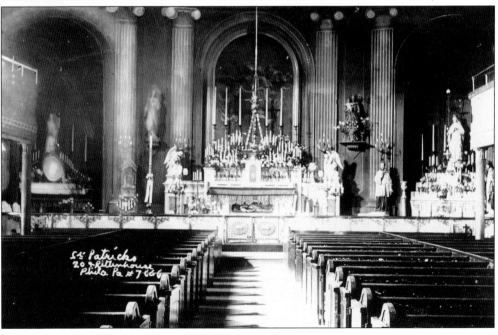

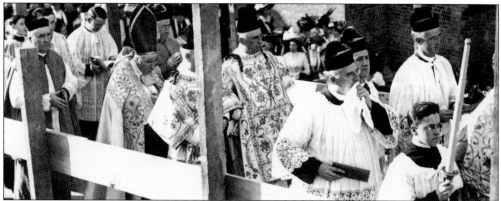

In 1910, the 1841 LeBrun church was demolished for a larger church to accommodate St. Patrick's growing congregation. On October 2, 1910, Catholic prelates from around the globe gathered to lay the cornerstone of Irish marble, presented by Cardinal Michael Logue of Ireland (seen above at left center, in cope and miter). On March 2, 1913, the majestic brick-and-marble basilica, designed by the firm of LaFarge and Morris to resemble an early Roman church, was dedicated. Today the St. Patrick's campus, with its church, rectory, and school, appears much as it did in the c. 1916 picture below. (St. Patrick's Church.)

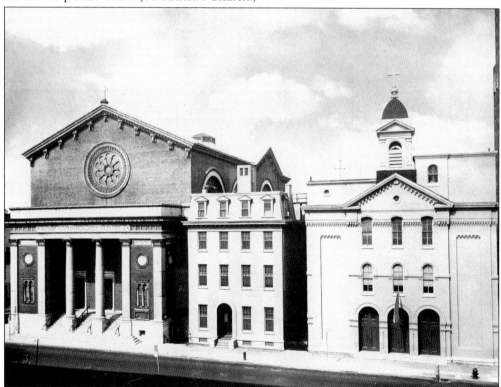

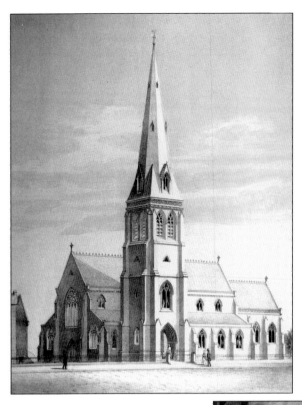

Completed in 1851, St. Mark's Episcopal Church at 1625 Locust Street was designed by John Notman, drawing on plans from the Ecclesiological Society of London. St. Mark's was founded by members of the Oxford movement, who attempted to restore Roman Catholic rituals that the Church of England had abandoned during the Reformation. St. Mark's was designed to be a "High Church" or Anglo-Catholic in manner and practice, reflecting an idealized English country parish church in the 14th-century Gothic style. This c. 1850 lithograph shows the brownstone church as it appeared shortly after its completion, looking northeast from Locust Street. (St. Mark's Episcopal Church.)

This c. 1890 photograph shows the rood screen separating the high altar from the nave of St. Mark's church. At the time of its completion, St. Mark's was one of only two Episcopal churches west of Broad Street. Within a decade, St. Mark's was one of the richest and most socially prominent congregations in the city, whose parishioners included Gen. George Gordon Meade, commander of the Union army at the Battle of Gettysburg in 1863. (St. Mark's Episcopal Church.)

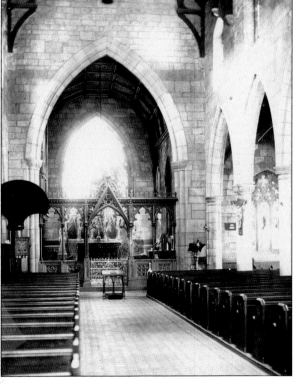

In 1900, Rodman Wanamaker, son of department store magnate John Wanamaker, lost his wife Fernanda. Rodman donated the funds to construct a Lady Chapel in his wife's memory. Designed by Cope and Stewardson and constructed of red sandstone, the Lady Chapel was built at the eastern end of St. Mark's between 1900 and 1902. The remains of Fernanda Wanamaker lie in the crypt beneath the chapel. Rodman Wanamaker, his second wife, and his children are buried at the Episcopal Church of St. James the Less in East Falls. (St. Mark's Episcopal Church.)

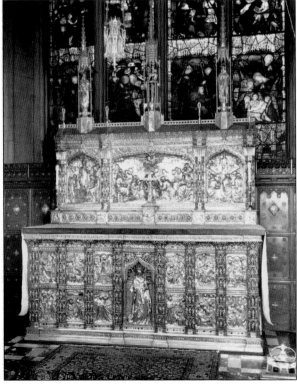

In 1909, the original altar in the Lady Chapel was replaced by a marble altar encased in silver. Designed by English jeweler Carl Krall, the silver altar contains 144 individually sculpted figures of saints and is decorated with 400 emeralds, sapphires, and other precious and semiprecious stones. The front of the altar shows the Virgin Mary holding the infant Jesus, surrounded by 12 scenes from her life. The original alabaster altar and reredos were moved to the front of the north aisle and rededicated to St. John. (St. Mark's Episcopal Church.)

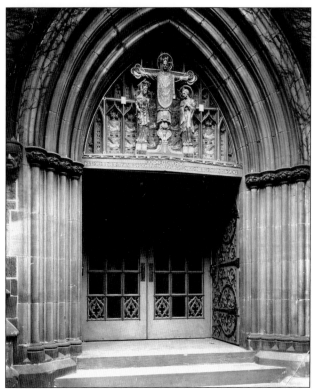

In 1923, the original doors on the south side of St. Mark's were replaced by a memorial entrance donated by Catherine Fiske and designed by Zantzinger, Borie and Medary. The heavy red doors are decorated with elaborate ironwork by Samuel Yellin. Above the doors is a stained-glass tympanum with a sculptural crucifixion, designed by Nicola D'Ascenzo and E. Maene. Below the polychrome figures of Christ the King, framed by the Virgin Mary and St. John, are words from Matthew 11:28: "Come unto me, all ye that travail and are heavy laden, and I will refresh you."

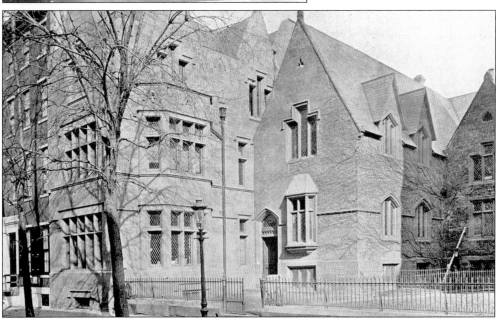

In 1892–1893, the firm of Hazlehurst and Huckel designed a new rectory for St. Mark's west of the church, replacing the original one at Locust and Eighteenth Streets. In 1953, historian Theo B. White wrote of "St. Mark's with its dependencies and garden; the whole fabric embowered in ivy, even to the top of the spire, a wall of green that shivered pleasantly in the breeze of spring." (St. Mark's Episcopal Church.)

Built between 1857 and 1859, the Church of the Holy Trinity (Episcopal) anchored Rittenhouse Square at its northwest corner. Designed by John Notman in the Norman Romanesque style, Holy Trinity was meant to be more "Low Church" or Protestant in practice than Gothic, "High Church" St. Mark's. Notman's original design for a 225-foot spire was rejected by the church's second rector, Phillips Brooks. Brooks thought that a spire pointed upward, signifying a God apart from men, while a lower tower would represent God on a closer level to man. This photograph, taken around 1860, shows the church without its tower. (Free Library of Philadelphia.)

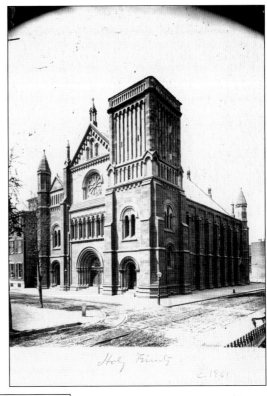

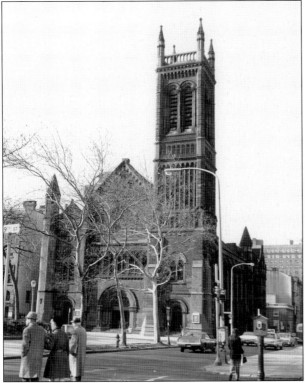

After a long standoff with the church's pro-spire vestry, Phillips Brooks won and a simpler, 110-foot tower designed by Fraser and Potter was completed in 1868 (seen here in 1969). In 1882, a 25-bell Belgian carillon was installed in the tower. After a 1999 restoration, the oldest manually operated carillon in the United States is still in service, providing music for the annual Christmas tree lighting in Rittenhouse Square. In addition, the church's two pipe organs make it an ideal location for concerts by the Bach Society, Curtis Institute of Music, and Chamber Orchestra of Philadelphia. (Free Library of Philadelphia.)

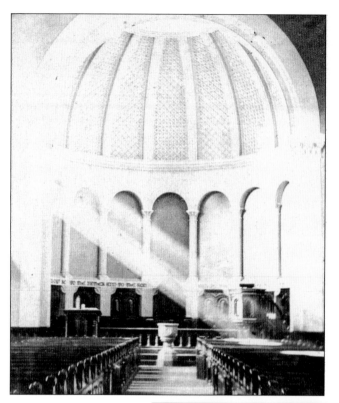

These photographs, taken a few years after Holy Trinity's completion, show the chancel at the church's west end (left) and the rose window above the church entrance at its east end (below). Originally, the church interior was relatively simple, with a basilica, trusses, and semicircular arches. (Church of the Holy Trinity.)

In 1879, the church appointed a committee to investigate "making improvements" to the building, including the "renovation of the entire interior." Gradually the church was filled with elaborate furnishings, including a monumental pulpit, bronze memorial plaques, and stained-glass windows by Tiffany and D'Ascenzo. (Church of the Holy Trinity.)

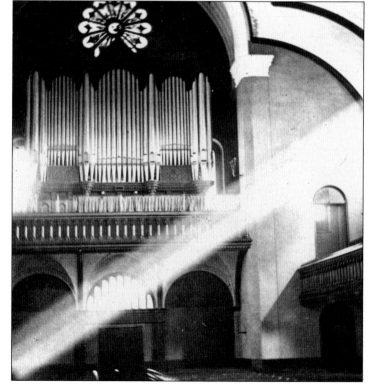

After his arrival in 1860, Holy Trinity's second rector, Philips Brooks, established the church as one of Philadelphia's most dynamic and prominent congregations. A passionate abolitionist, Brooks witnessed the bloody aftermath of the Battle of Gettysburg in 1863. After the Civil War ended, Brooks took a sabbatical, which included a Christmas visit to Bethlehem in Palestine. His experience inspired him to write the lyrics for a hymn, "O Little Town of Bethlehem," which Holy Trinity organist Lewis Redner set to music. Brooks left Holy Trinity in 1869 to become rector of Trinity Church in Boston. "O Little Town of Bethlehem" has become one of America's most beloved Christmas carols.

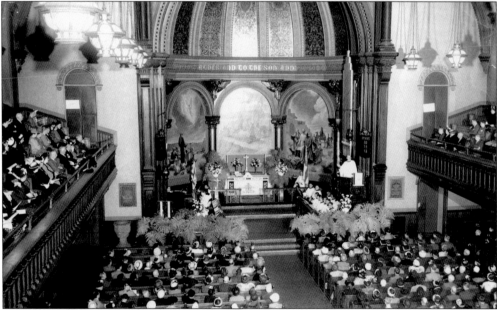

In 1941, the chancel of Holy Trinity (seen around 1950) was redecorated with murals painted by Hildreth Miere commemorating "O Little Town of Bethlehem." Despite its heritage, the Church of the Holy Trinity was almost demolished in the late 1960s for a high-rise apartment building. Although the diocesan office next door (the former Rogers-Cassatt mansion) was destroyed, the church itself survived thanks to community protests. (Church of the Holy Trinity.)

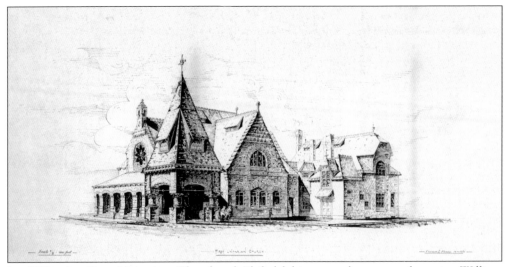

In 1883, the First Unitarian Church of Philadelphia moved uptown from its William Strickland–designed church at Tenth and Locust Streets. Pastor William Henry Furness selected his son Frank Furness to design the new church at Chestnut and Twenty-first Streets. Furness's iconoclastic design (above) featured a rusticated facade, hipped and cross-gabled roof, and massive corner porch with tower. The photograph below shows the church when completed in 1886. Sadly, the exterior was altered during the 20th century by the removal of the corner tower in 1921 and by the smoothing of the rock-faced facade in the 1950s. (First Unitarian Church of Philadelphia.)

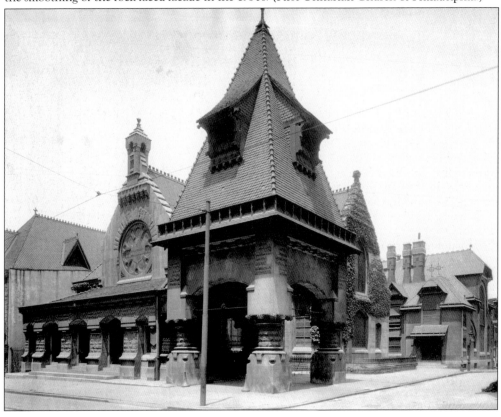

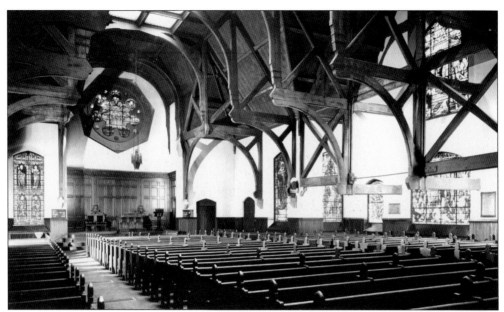

As originally designed by Frank Furness, the interior of the First Unitarian Church was vibrantly colorful, with cerulean blue walls and a red ceiling decorated with gold stencils. During the 1920s renovation, the interior was painted gray to tone down Furness's "vulgar" color scheme. In 1980, the church's interior was restored to its original Victorian appearance. (First Unitarian Church of Philadelphia.)

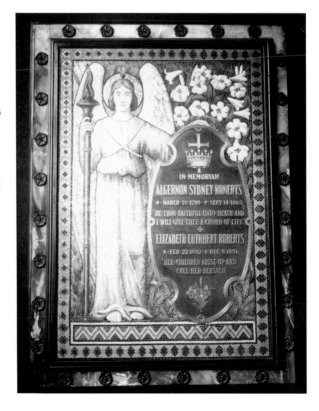

Originally, the church's interior was sparsely furnished, with clear-glass windows in geometric and floral patterns that flooded the space with light. In 1889, the first Tiffany stained-glass window commissioned in Philadelphia was installed in the church. Over the next few decades, the remaining clear glass was replaced with more stained-glass windows, enriching the church's beauty but darkening its interior. Elaborate wall memorials appeared, including this beautiful mosaic honoring the family of Algernon Sydney Roberts, owner of the Pencoyd Iron Works and resident of the Physick-Roberts House on Walnut Street. (First Unitarian Church of Philadelphia.)

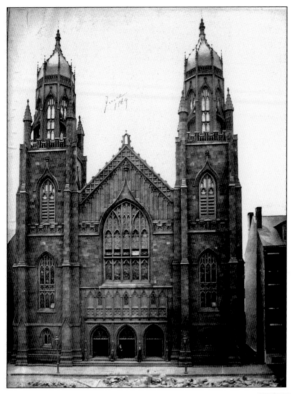

The Calvary Presbyterian Church at 1508–1514 Locust Street was designed by John Notman and built between 1851 and 1853. The unusual design, "in the perpendicular style of Gothic architecture, as it prevailed in the fifteenth century," featured twin towers topped by octagonal turrets and domes framed by a double set of spires. In 1869, church member Samuel Sloan designed an adjoining chapel. Despite its rich architectural heritage, the church was demolished after its congregation merged with the First Presbyterian Church in 1930. (Free Library of Philadelphia.)

In 1871, St. James' Episcopal Church moved to a new brick church designed by Fraser, Furness, and Hewitt at Twenty-second and Walnut Streets. In 1886, G. W. and W. D. Hewitt added a soaring sandstone and granite tower with a sculpted band around its base. The richly decorated interior included mosaics of the 12 apostles, stained glass by D'Ascenzo Studios, brass candelabras by Samuel Yellin, and a memorial tablet to Henry Charles Lea designed by Paul Philippe Cret. During the 20th century, the once-affluent church declined. In 1945, the property was sold to the Atlantic Refining Company, which replaced the structure with a gas station.

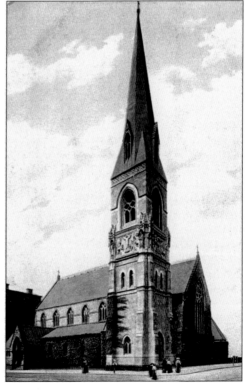

Organized in 1698, the First Baptist Church of Philadelphia is considered by many to be the first true Baptist congregation in America. In 1900, the church moved from Broad and Arch Streets to its new home on Seventeenth Street between Sansom and Moravian Streets. Designed by Edgar V. Seeler, the Byzantine Romanesque–style structure boasts an octagonal tower covering a monumental interior dome reminiscent of Hagia Sophia in Istanbul. (James Hill Jr.)

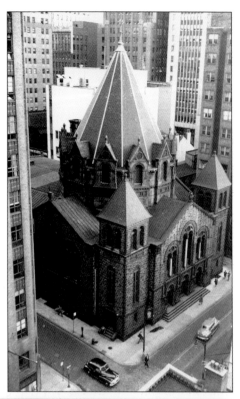

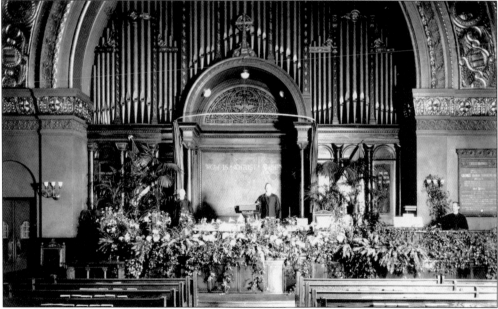

Some church members wondered whether the interior was "not a bit elaborate and ornate for Baptists!" The barrel-vaulted auditorium, in the form of a Greek cross, is decorated with stained-glass windows and colorful mosaics. This photograph shows the chancel decorated for an Easter Sunday, around 1900. Despite a 1949 fire that gutted the interior, the church has been almost completely restored to its original glory. (Free Library of Philadelphia.)

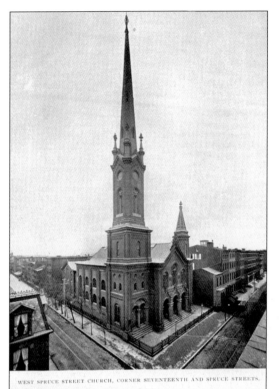

WEST SPRUCE STREET CHURCH, CORNER SEVENTEENTH AND SPRUCE STREETS.

In 1855, the Tenth Presbyterian Church (then at Walnut and Twelfth Streets) established a "daughter" church called the West Spruce Street Presbyterian Church at the southwest corner of Spruce and Seventeenth Streets. Designed by church deacon John J. McArthur, the new structure was in the Lombard Romanesque manner, with rounded doors and windows and two steeples in different styles. At 250 feet, the east tower was the tallest point in the city at the time. (Free Library of Philadelphia.)

In 1893, the Tenth Presbyterian Church moved uptown to Spruce and Seventeenth Streets and merged with the West Spruce Street church. At that time, Frank Miles Day altered the church's exterior to make it appear more Byzantine, following the fashions for church design at that time. In 1912, the Tenth Presbyterian Church's towering spires were removed due to structural damage and neighbors' concerns over their possible collapse. (Tenth Presbyterian Church of Philadelphia.)

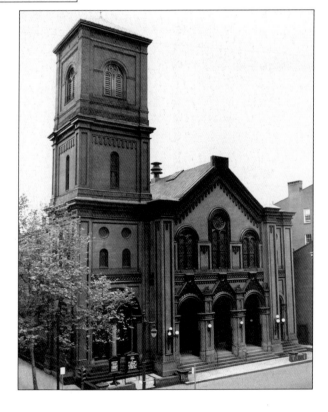

The original interior of the Tenth Presbyterian Church, seen around 1861, was also designed by John McArthur in the Lombard Romanesque style. Originally the church boasted a vaulted ceiling with highly decorated arched braces, a towering central pulpit, and elaborate gasoliers. (Tenth Presbyterian Church of Philadelphia.)

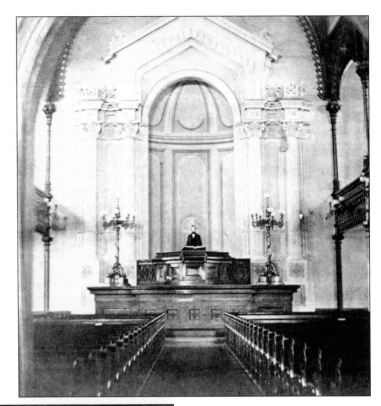

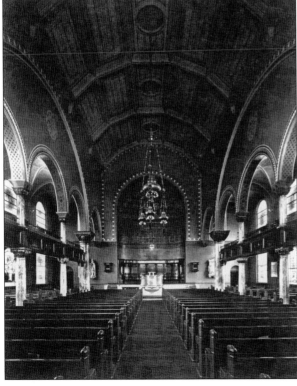

At the same time that Frank Miles Day redesigned the church's exterior, he also altered its interior in an ornate neo-Byzantine style with elaborate stenciled designs and Tiffany stained-glass windows. Today the church interior resembles this c. 1893 photograph, with the exception of the Oriental-style chandeliers, which have been removed. (Tenth Presbyterian Church of Philadelphia.)

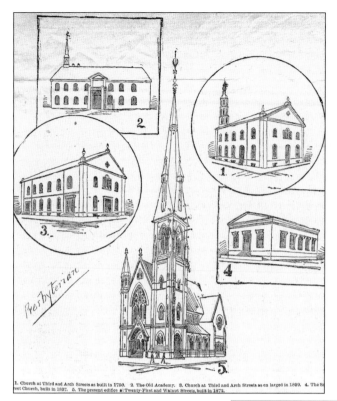

In 1872, the Second Presbyterian Church moved from Seventh Street below Arch Street to a new structure at Twenty-first and Walnut Streets, a neighborhood described by one reporter as "a part of Philadelphia which is rapidly improving, and where many of the abodes of wealth and refinement are to be found." Designed by Henry Augustus Sims in a style described as "French Gothic with some early English features," the church was constructed of granite, brownstone, redstone, bluestone, sandstone, and green serpentine. The newly finished church with its original spire is featured prominently in a *c.* 1876 newspaper illustration on notable churches in Philadelphia. (Free Library of Philadelphia.)

1. Church at Third and Arch Streets as built in 1750. 2. The Old Academy. 3. Church at Third and Arch Streets as enlarged in 1809. 4. The Se[...]eet Church, built in 1837. 5. The present edifice at Twenty-First and Walnut Streets, built in 1872.

After the church's original spire burned in 1900, Frank Furness designed a new bell tower in an asymmetrical style, with an exaggeratedly enlarged spire at its southeast corner. In 1949, the Second Presbyterian Church reunited with its parent church, from which it had split in 1743. The First Presbyterian Church moved from its church at 1508–1514 Locust Street to the Sims-Furness structure, which became in turn the First Presbyterian Church. (L. M. Arrigale.)

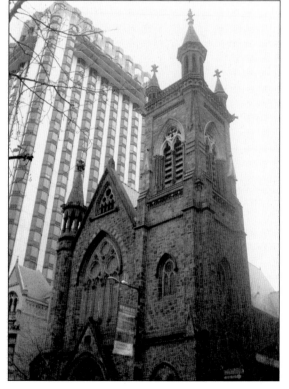

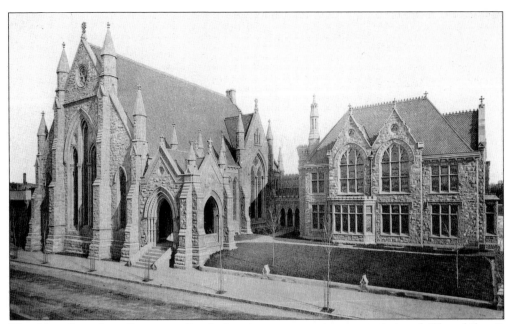

The New Jerusalem Society, a Swedenborgian congregation, commissioned Theophilus P. Chandler to design a new church in the English Gothic style at 2129 Chestnut Street, next to the First Unitarian Church. Completed in 1883, the church and parish house were laid out around a central courtyard. The congregation sold the buildings in 1986 to Graduate Health Systems, which converted them to offices while preserving their exteriors. (Free Library of Philadelphia.)

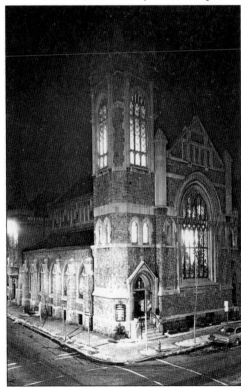

The changing demographics of Rittenhouse Square are demonstrated by the Temple Beth Zion–Beth Israel at the corner of Eighteenth and Spruce Streets. The Gothic structure was built in 1894 as the Church of the Covenant. In 1954, it became home of the Temple Beth Zion–Beth Israel, which had been meeting at the Lit mansion at Nineteenth and Delancey Streets. Architect Beryl Price transformed the church into a "jewel of a synagogue," with raw silk and gold thread curtains surrounding the ark, mosaics, murals, and stained-glass windows with early Biblical themes designed by Vincent Filipone. (Temple Beth Zion–Beth Israel.)

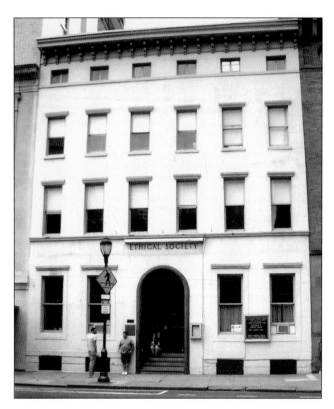

Founded in 1876, the Ethical Culture Movement is a humanistic, socially active ethos that combines teachings from various philosophies and religions to encourage the knowledge, love, and practice of the "right." The Philadelphia Ethical Society, the local branch of the Ethical Culture Movement, was founded in 1885 by S. Burns Weston. The society met at various locations until 1930, when it purchased two adjoining residences at 1906 and 1908 South Rittenhouse Square, combining them to form its current headquarters. (Robert Morris Skaler.)

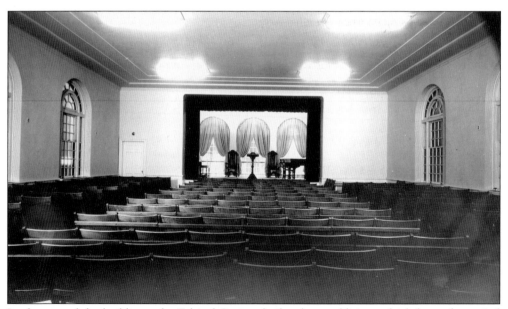

In the rear of the buildings, the Ethical Society built a large addition, which housed a recital hall where Marian Anderson performed in the 1930s and Bob Dylan performed in the 1960s. (Philadelphia Ethical Society.)

Four

THE SOCIAL LIFE
RITTENHOUSE SQUARE INSTITUTIONS

By 1900, a well-bred Philadelphian might never have had to venture beyond the city's southwest quadrant, except for his annual summer pilgrimage to Bar Harbor. Rittenhouse Square had become the heart of a self-contained world bordered by Broad Street, Market Street, South Street, and the Schuylkill River. The elegant homes on and around the square were surrounded by offices, churches, boutiques, artistic institutions, and clubs.

While the patrician Philadelphia Club remained entrenched at Walnut and Thirteenth Streets, other clubs followed their members west. The solidly Republican Union League had left its first home at 1118 Chestnut Street for a Second Empire mansion on South Broad Street as early as 1865. In 1878, the Social Art Club moved from 1525 Chestnut Street to 1811 Walnut Street, changing its name to the Rittenhouse Club.

Over the next 50 years, these two pioneers would be joined by more than a dozen clubs catering to different social and professional cliques, including the Acorn, Art, Civic, Clover, Cosmopolitan, Four-in-Hand, Locust, Print, Racquet, and University Clubs. Many clubs were located between Broad Street and Rittenhouse Square, providing their mostly male members with a convenient stop between the office and home.

Besides supporting a lively social life, Rittenhouse Square residents promoted cultural institutions, including the Philadelphia Orchestra, the Pennsylvania Academy of the Fine Arts, and the Philadelphia Museum of Art. As city dwellers moved to the suburbs in the early 20th century, Rittenhouse Square mansions became home to cultural institutions like the Philadelphia Art Alliance and the Curtis Institute of Music. Meanwhile, former residences on Chestnut, Locust, and Walnut Streets were reborn as art galleries, antique stores, and upscale boutiques.

Today cultural institutions give Rittenhouse Square much of its distinction. Students from the Curtis Institute of Music give free outdoor concerts in the square. The Philadelphia Art Alliance continues to provide a forum for new artists. For many years, Plays and Players Theater housed the renowned Philadelphia Theatre Company as well as its own repertory company.

In contrast, changing residential and social patterns have doomed many clubs to extinction. While the Union League, Racquet, and Acorn have survived, other clubs are now only memories, including the Locust and Rittenhouse. The latter institution, which Henry James had once praised for its "large friendliness, ordered charm and perfect peace," was recently demolished except for its facade, which will front a new high-rise condominium.

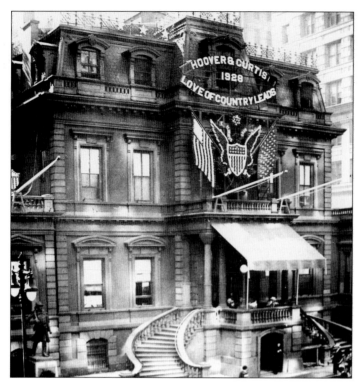

Founded in 1862 to bolster northern loyalty during the Civil War, the Union Club evolved into a political and social organization for Philadelphia's Republican elite. In 1865, the renamed Union League moved from 1118 Chestnut Street to South Broad and Sansom Streets. Designed by John Fraser, the league's clubhouse (shown here before the 1928 presidential election) became a second home to many Rittenhouse Square residents. (Free Library of Philadelphia.)

In 1911, an annex fronting on Fifteenth Street was added to the rear of the original building. Designed by Horace Trumbauer, its striking difference from the clubhouse reflected changing tastes in the half-century since the league's founding. (Free Library of Philadelphia.)

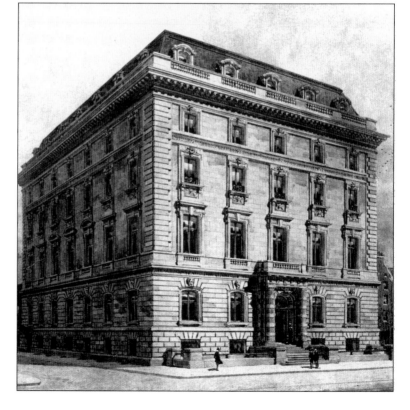

In 1878, the Social Art Club, founded in 1875 as a literary society, moved from 1525 Chestnut Street to 1811 Walnut Street, the first house built on Rittenhouse Square by James Harper in the 1840s (with the marble portico). To celebrate its move, the organization changed its name to the Rittenhouse Club. Founding member Frank Furness redesigned the building, covering the red brick facade with white marble. In 1890, the club purchased 1813 Walnut Street (at far left) and connected the two buildings' interiors. By 1900, the Rittenhouse Club was one of the city's most fashionable retreats for men, described by one guide as a "junior ultra swell club." (James Hill Jr.)

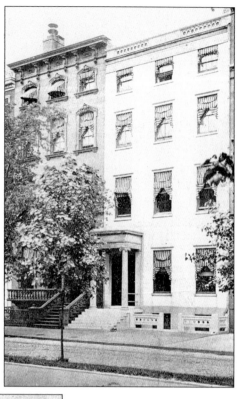

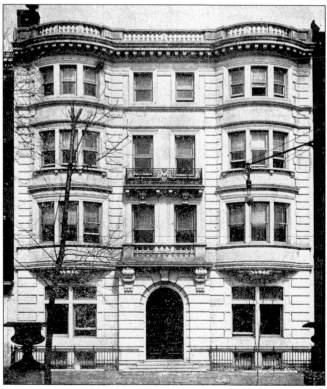

In 1901, the firm of Newman, Woodman and Harris created a single Beaux-Arts facade for the Rittenhouse Club's two structures and redesigned the interiors as a coherent entity. The elegantly furnished club featured a library designed by Paul Philippe Cret, furniture by Frank Furness, oriental carpets, and oil paintings. After the 1970s, membership declined and the building suffered from deferred maintenance. Finally, the club auctioned its furnishings and put its clubhouse on the market in 1993. After standing vacant for over a decade, the Rittenhouse Club was demolished in 2006, except for its facade, which will serve as a side entrance to a new luxury condominium.

65

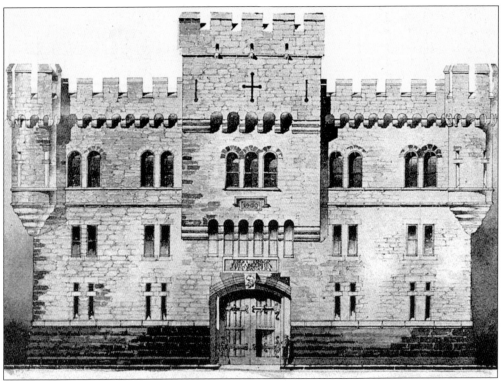

Founded in November 1774, the First Troop Philadelphia City Calvary (also known as the First City Troop) is the oldest mounted military unit in continuous active service in the United States. When its first permanent armory at Twenty-first and Ludlow Streets grew too small, the First City Troop commissioned Newman Woodman and Harris to build a fortresslike structure at Twenty-third and Ranstead Streets in 1901. Shown above is an architect's concept of the building; the finished structure is shown below. The First City Troop, now part of the Pennsylvania Army National Guard, still occupies the structure.

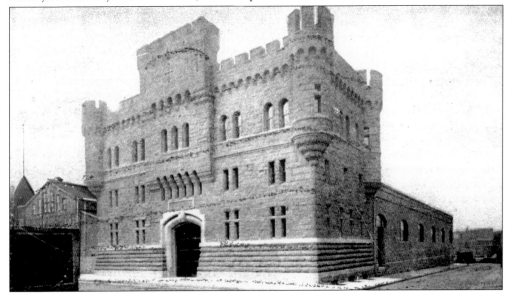

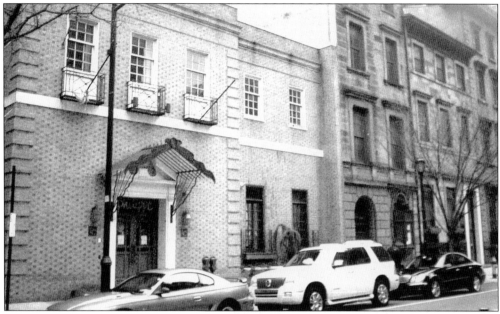

Until the 1960s, Jews were routinely excluded from many Philadelphia clubs. In response, six prominent Jewish businessmen founded the Locust Club in 1920 as a successor to an earlier organization called the Mercantile Club, originally located on North Broad Street. The Locust Club complex—a Colonial Revival structure built in 1960 and a c. 1850 brownstone designed by John Notman—was located at 1612–1618 Locust Street. (L. M. Arrigale.)

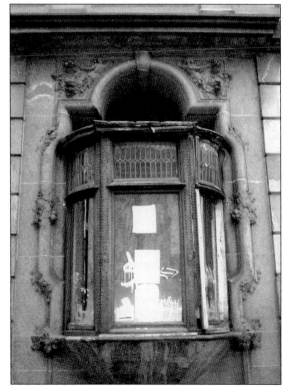

As anti-Semitism diminished, the "Jewish Union League" lost members to other organizations, and the Locust Club finally closed its doors in 1999. In 2007, philanthropist H. F. "Gerry" Lenfest purchased its buildings and donated them to the Curtis Institute of Music. Curtis has announced plans to replace the former Locust Club with two structures designed by Venturi, Scott Brown, and Associates, which would house an orchestral rehearsal hall, studios, cafeteria, and dorms for 88 students. While the entire 1960 structure would be demolished, the facade of the 1850 John Notman brownstone (the bay window of which is seen here) would be incorporated into the new structures. (L. M. Arrigale.)

In 1907, the Racquet Club of Philadelphia, founded in 1889 at 923 Walnut Street, moved into a new building at 213–225 South Sixteenth Street. The new clubhouse, designed by Horace Trumbauer, was a simple yet elegant brick-and-marble structure in the newly fashionable Georgian Revival style. George D. Widener, a founding member of the Racquet Club, personally selected Trumbauer, who had designed numerous buildings for his family, including the Widener Building on Penn Square and the Widener country estate, Lynnewood Hall. In April 1912, George D. Widener would be lost on the *Titanic*, along with his son Harry. (Racquet Club of Philadelphia.)

The opening of the elegantly appointed Racquet Club was prominently featured in all of the major Philadelphia papers. The Sunday *Public Ledger* devoted an entire page to the club's decor, including the picturesque Grill Room decorated with Enfield tiles, the Billiard Room, and the indoor pool (considered an engineering innovation because it was on an upper floor, rather than in the basement). The club's luxurious interiors, including a wood-paneled locker room and marble-walled steam room, were featured in Jonathan Demme's 1993 film *Philadelphia*. (Racquet Club of Philadelphia.)

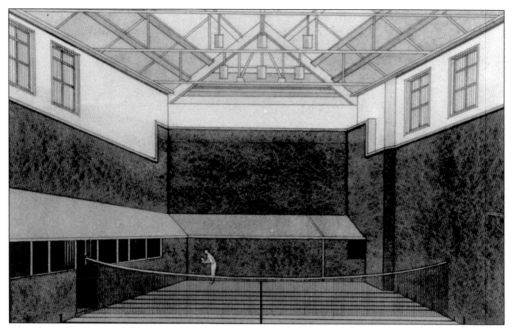

Thanks to its state-of-the-art facilities, the Racquet Club soon became one of the top centers for racquet sports in the United States. It was the first private club in America to have a squash racquets court, and to introduce hardball squash doubles. It also possesses one of only eight court tennis courts in the world (above), where tennis is played as it was in 12th century France. (Racquet Club of Philadelphia.)

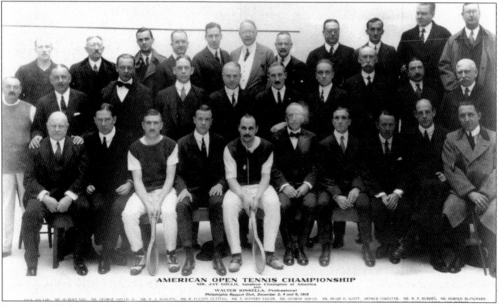

AMERICAN OPEN TENNIS CHAMPIONSHIP
MR. JAY GOULD, Amateur Champion of America
AND
WALTER KINSELLA, Professional
Philadelphia Racquet Club, December 2, 4 and 6, 1919

Racquet Club member Jay Gould, grandson of the infamous New York financier, dominated national court tennis for more than two decades. He held the national singles court tennis championship from 1906 to 1917 and again from 1920 to 1925. He poses in the center of the front row with other Racquet Club members during the 1919 American Open Tennis Championship. (Racquet Club of Philadelphia.)

Located between Locust and Spruce Streets south of Rittenhouse Square, Latimer Street was lined with stables and servants' housing for nearby mansions during the 19th century. In the early 20th century, many of these modest buildings were renovated as pieds-à-terre or clubhouses. Thanks to the Cosmopolitan Club, Print Club, and the Colonial Dames of America, cozy Latimer Street became Rittenhouse Square's answer to Camac Street, the tiny "Street of Clubs" downtown. The 1929 print at left shows Latimer Street, looking west from Sixteenth Street toward the square.

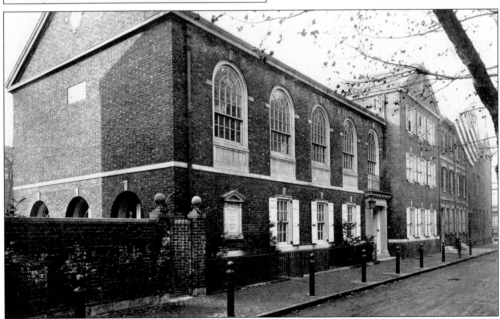

The National Society of the Colonial Dames of America restricts its membership to female descendants of any American colonist "of worthy life . . . who rendered efficient service to his country during the Colonial period." The Pennsylvania headquarters of the society, located at 1630 Latimer Street, was designed by Ritter and Shay in 1921. Today society members focus on education and the preservation of historic sites.

The Print Club was founded in 1915 to support the "dissemination, study, production, and collection of works by printmakers, American and foreign." In 1927, it moved into a former carriage house (right) at 1614 Latimer Street redesigned by Edmund B. Gilchrist. Longtime director Berthe von Moschzisker (below), who led the club from 1944 to 1969, spearheaded the collection of prints by such then-emerging artists as Jasper Johns and Robert Rauschenberg. In 1996, the Print Club changed its name to the Print Center, to reflect its commitment to promoting prints and photography to the larger community through exhibitions and education. (Philadelphia Print Center.)

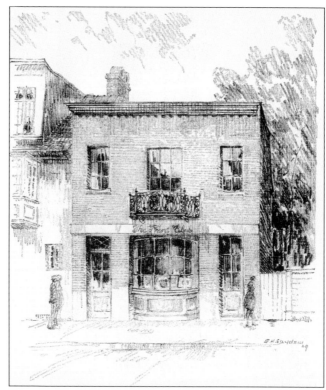

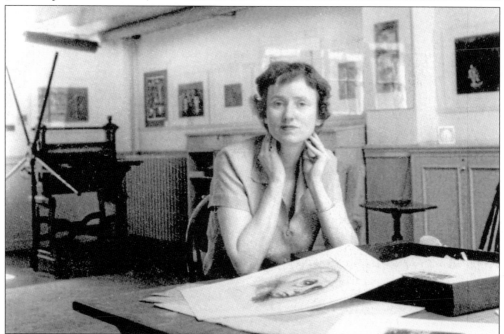

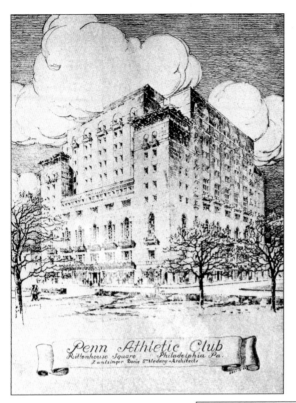

Penn Athletic Club
Rittenhouse Square · Philadelphia Pa.
Zantzinger Borie & Medary · Architects

In 1926, the Joseph Harrison mansion on the east side of Rittenhouse Square was demolished for a clubhouse for the Penn Athletic Club, a social and athletic association founded in 1923. The firm of Zantzinger, Borie and Medary was commissioned to design an orange brick art deco skyscraper, seen at left. The 16-story building featured a series of decorative medallions across the facade showing athletes competing in various events.

The Penn Athletic Club's steel skeleton rises on the Harrison mansion site, looking northeast from the corner of Locust and Eighteenth Streets toward Philadelphia City Hall tower. The roof of the Curtis Institute of Music is visible in the foreground. When it opened in 1928, the club offered modern athletic facilities, fine dining, and luxurious quarters. Businessmen could even watch a noontime boxing match while enjoying French cuisine at a linen-covered table. Within a year of opening, the club had over 11,000 members. (Free Library of Philadelphia.)

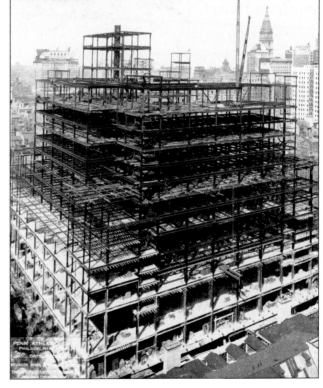

The 1929 stock market crash and ensuing depression caused the Penn Athletic Club's membership to drop from over 11,000 to less than 4,000. Despite this, the club managed to survive the 1930s, attracting members with social events like the 1937 rooftop cabaret shown at right. Unlike most Philadelphia clubs at the time, the Penn Athletic Club was open to both men and women. Female members, however, were expected to use a side entrance on Locust Street, while men used the main entrance on Eighteenth Street. (Free Library of Philadelphia.)

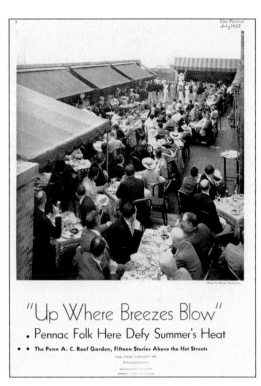

"Up Where Breezes Blow"
• Pennac Folk Here Defy Summer's Heat
• • The Penn A. C. Roof Garden, Fifteen Stories Above the Hot Streets

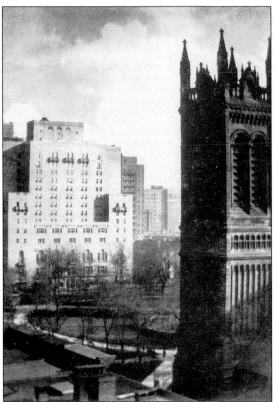

In the c. 1940 view at left, the Penn Athletic Club is seen with the tower of Holy Trinity Church in the foreground. With the advent of World War II, the club moved to the Fell–Van Rensselaer mansion at 1801 Walnut Street, and sold its building to the United States government in 1942. For many years, the former clubhouse was known as the Signal Corps Building. After being used as offices for many years, it became the Rittenhouse Regency apartments and Sheraton Rittenhouse Square Hotel. In 2005–2007, the building was redeveloped as the Parc Rittenhouse Condominiums and Club. (Free Library of Philadelphia.)

The Philadelphia Art Alliance was founded in 1915 by Christine Wetherill Stevenson and 33 fellow Philadelphians to promote the arts in America as Europe was engulfed by war. The alliance opened in 1918 in two brownstones at 1823–1825 Walnut Street. (Philadelphia Art Alliance.)

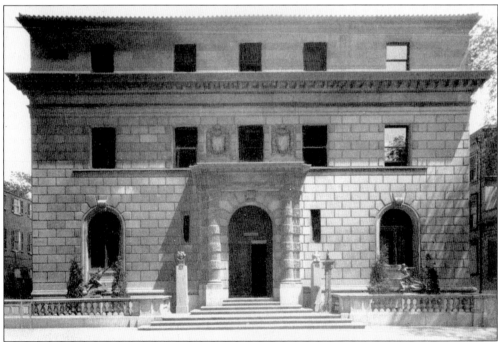

Four years after Stevenson's death in 1922, the Philadelphia Art Alliance purchased the residence of her father, Samuel Price Wetherill, at 251 South Eighteenth Street, opening its first exhibit there in 1926. Plans to replace the mansion with a Tudor tower or art deco skyscraper foundered during the Depression, and the alliance occupies the same quarters today. (Philadelphia Art Alliance.)

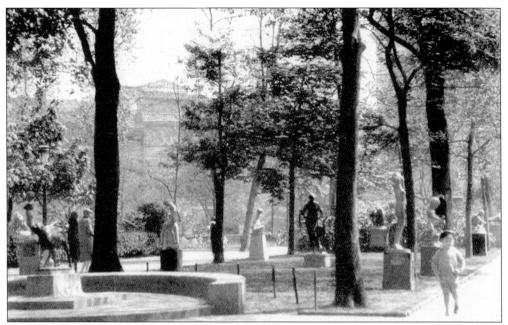

Since its founding, the Philadelphia Art Alliance has striven to promote the arts in Philadelphia through exhibitions, lectures, performances, and competitions. Starting in 1920, the alliance sponsored the Outdoor Sculpture Show in Rittenhouse Square, a tradition that continued until 1942, when it was transferred to the Philadelphia Museum of Art. (Philadelphia Art Alliance.)

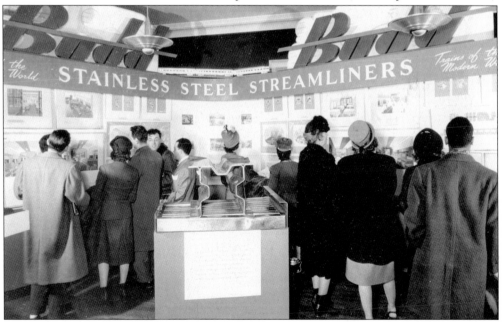

The Philadelphia Art Alliance has frequently gone beyond the boundaries of traditional art to promote outstanding design. In the late 1940s, it mounted an exhibit of industrial designs by Philadelphia's Budd Company, a leading manufacturer of railroad and subway cars, automobile bodies, and aircraft. In the foreground stands a cross-section of a stainless steel Center Sill, "the 'Backbone' of The Budd Company's modern railway cars." (Philadelphia Art Alliance.)

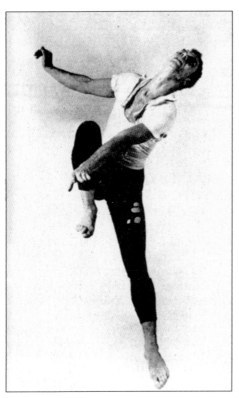

The Philadelphia Art Alliance's founder, Christine Wetherill Stevenson, wanted the organization to embrace all aspects of art, both performing and plastic. From the beginning, the Philadelphia Art Alliance has featured performances by such artists as Gertrude Stein, Nadia Boulanger, Aaron Copland, and Twyla Tharp. In 1961, the Philadelphia Art Alliance sponsored a dance recital by Merce Cunningham (left), with musical director John Cage, at Plays and Players Theater. (Philadelphia Art Alliance.)

Beginning in 1940, the Philadelphia Art Alliance has awarded an annual medal of achievement to outstanding contributors to the arts. The first recipients were Philadelphia Orchestra conductor Eugene Ormandy, artist N. C. Wyeth, and Lauritz Eichner. Since then, medal of achievement recipients have included Arthur B. Carles, Henry Lee Willet, Marian Anderson, Catherine Drinker Bowen, Edmund N. Bacon, Louis I. Kahn, Martha Graham, and Helen Hayes (left), seen at the reception following her award ceremony in 1968. (Philadelphia Art Alliance.)

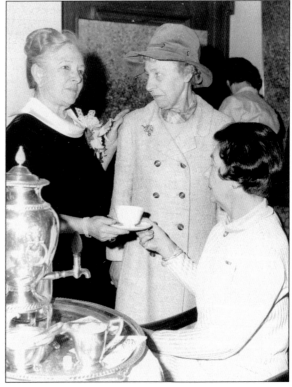

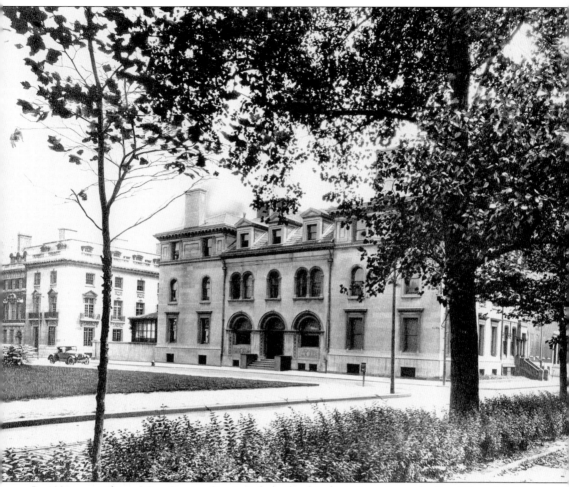

In 1924, music lover Mary Louise Curtis Bok (wife of *Ladies' Home Journal* editor Edward Bok) founded the Curtis Institute of Music as a free academy for scholarship students. Bok and her father, Curtis Publications founder Cyrus Curtis, purchased three mansions on Locust and Eighteenth Streets for the institute. This *c.* 1927 photograph (looking southeast from Eighteenth Street toward Locust) shows the George William Childs Drexel house (1726 Locust) at center, today Curtis Hall, the institute's main building. A recital hall later replaced its solarium. To the left is the former Theodore Cramp house (1720 Locust), which was renamed Knapp Hall in honor of Bok's mother Louisa Knapp Curtis. The Edward Sibley house (235 South Eighteenth Street) is visible to the right. The lot at left has been cleared for construction of the Penn Athletic Club. (Curtis Institute of Music.)

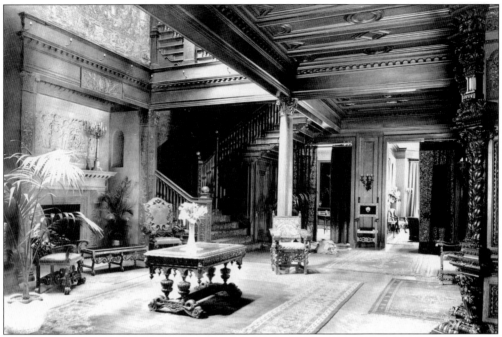

Before its conversion for use by the Curtis Institute of Music in 1924, the Drexel mansion (designed in 1893 by Peabody and Stearns) was one of the most luxurious residences on Rittenhouse Square. Seen above is its entrance hall around 1900, which survives relatively intact as the common room in Curtis Hall. Below is the Drexel drawing room, also around 1900. Before moving out, the Drexel family bequeathed many of their possessions to the new institute, including the gilded and decorated Steinway piano seen below, which stands in front of the common room fireplace today. (Curtis Institute of Music.)

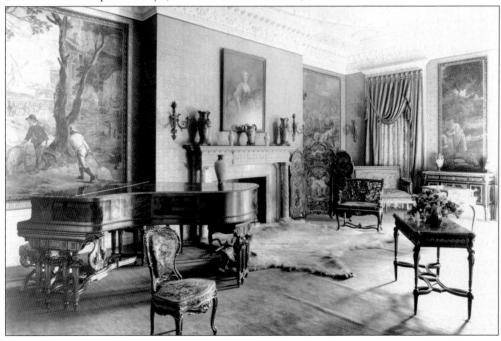

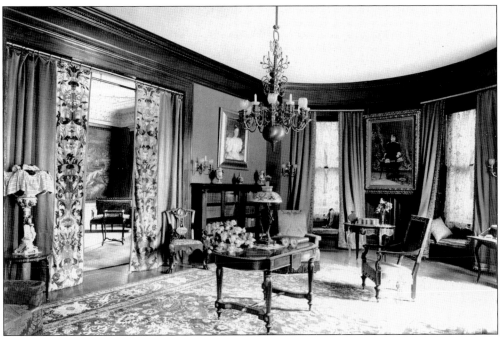

The photograph above shows the front parlor in the Drexel mansion around 1920. The photograph below shows the same room three decades later when it was the Bok Room in the institute's main building. The woman standing at left is Anna Moffo, later a leading soprano at the Metropolitan Opera. Classical violist Michael Tree, later a founding member of both the Guarneri String Quartet and the Marlboro Trio, reads by the window at right. Other prominent Curtis alumni include Samuel Barber, Leonard Bernstein, Gian Carlo Menotti, and Ned Rorem. (Curtis Institute of Music.)

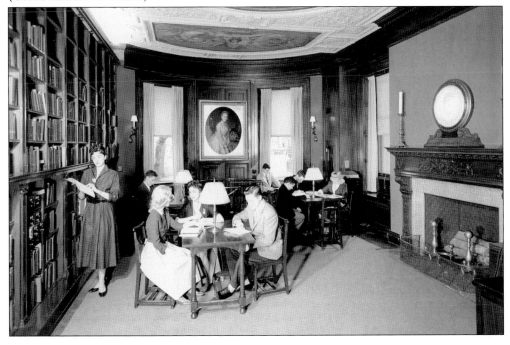

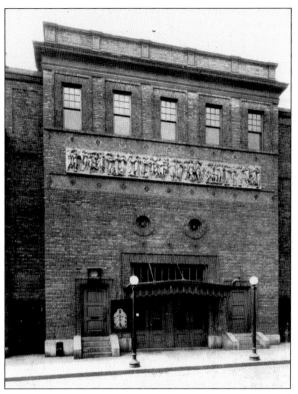

Plays and Players Theater at 1714 Delancey Street (shown here around 1915) is the oldest community theater in continuous operation in the United States. Designed by Amos W. Barnes as the Little Theatre in 1912, the 336-seat theater was acquired by Plays and Players in 1921. Over the years, stage luminaries like John Drew, Otis Skinner, and John Barrymore have appeared here. The theater housed the Philadelphia Theater Company for over 30 years until Philadelphia Theater Company's move to a new facility on South Broad Street in 2007. (Free Library of Philadelphia.)

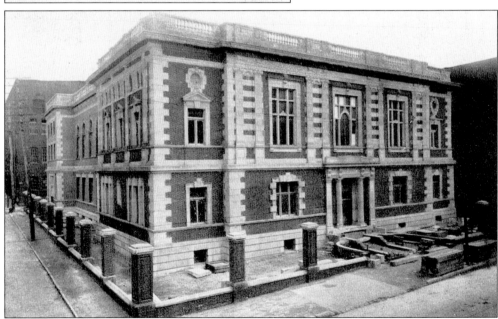

The College of Physicians in Philadelphia, the oldest professional medical organization in the country, was founded in 1787 to advance medicine through education and public programs. In 1907, the college moved into its current home at 19 South Twenty-second Street, designed by Cope and Stewardson (shown here shortly before completion). Today the college also houses the world-famous Mütter Museum of anatomical and pathological specimens.

The Rosenbach Museum and Library, located in an 1865 brick townhouse at 2010 Delancey Place, is the former home and office of antiquarian book and manuscript dealer Dr. A. S. W. Rosenbach and his brother, antiques dealer Philip H. Rosenbach. After the Rosenbach brothers died in the 1950s, the house became a nonprofit museum and library. Among its 25,000 rare books and 100,000 manuscripts are the *Bay Psalm Book*, the first book printed in America in 1640; Erasmus's 1519 edition of the New Testament, with engravings by Holbein; and the manuscript for James Joyce's *Ulysses*. (Rosenbach Museum and Library.)

Dr. A. S. W. Rosenbach, seen in his library around 1930, held few illusions about the competitiveness of his fellow book collectors. In his 1927 biography, *Books and Bidders: Adventures of a Bibliophile*, he wrote, "The beautiful thing about the book business is that you must be constantly on your guard. . . . The atmosphere of Wall Street is that of a Quaker meetinghouse beside it." (Rosenbach Museum and Library.)

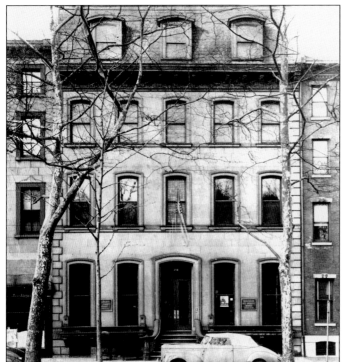

The Philadelphia City Institute was founded in 1852 for "the promotion of the moral and intellectual improvement of young persons." First located at Eighteenth and Chestnut Streets, the institute offered a library, lectures, concerts, and night classes. Shown is the exterior of the library around 1935. (Free Library of Philadelphia.)

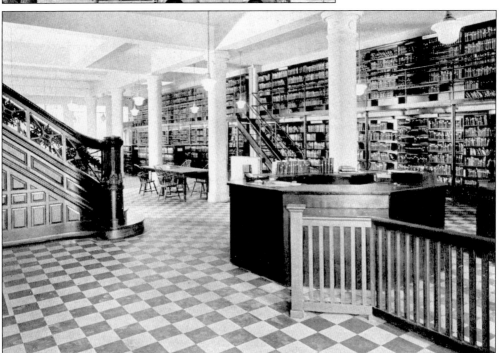

In 1923, the institute moved to the former Craige Lippincott residence at 218 South Nineteenth Street, becoming a Free Library branch in 1944. Shown here is the main reading room. Since 1957, the library has occupied the first floor and basement of an apartment building erected on the Lippincott mansion site. (Free Library of Philadelphia.)

Five

THE YEARS OF CHANGE
1913–1949

By 1913, Rittenhouse Square began to change as society's leaders started to move to Philadelphia's suburbs. Some decided to give up their mansions for the convenience of apartment life. To accommodate these new residential patterns, the first high-rise apartment was built on the south side of Rittenhouse Square in 1913. Other apartment houses were built prior to World War I on Spruce and Locust Streets east of Sixteenth Street. The beauty of the tree-shaded square helped to stabilize the area, which was still surrounded by many large homes. Nearby, elegant Delancey Place maintained its quiet residential character and 19th-century charm.

During the 1920s, there was a building boom on the square with the construction of several major apartment buildings, including the Wellington, Rittenhouse Plaza, 1900 Rittenhouse Square, and Chateau Crillion. The Penn Athletic Club was built on the site of the Harrison Mansion, and the upscale Barclay, Drake, and Warwick Hotels also opened. Meanwhile, individual residences were adapted to other uses: the Philadelphia Art Alliance moved into the Wetherill mansion, and the Curtis Institute of Music made the Drexel mansion its new home. Servants' houses and stables on surrounding side streets became home to artistic and private clubs.

The Depression brought construction to a screeching halt; nothing was built on the square from 1929 until the 1950s. Many of the elegant brownstones on Walnut, Locust, and Spruce Streets west of Sixteenth Street became seedy boardinghouses. Nevertheless, the Depression and World War II did not stop such annual events as the Rittenhouse Square Easter parade, Rittenhouse Square Flower Market, and Clothes Line Art Exhibit from continuing, well-attended and well-loved by local residents.

While the area around Rittenhouse Square suffered, the district's northern edge flourished during this period. With no suburban malls, shoppers from around the region flocked to the heart of the city. West Market Street was lined with luxurious movie palaces showing the films of Hollywood's golden age. While East Market Street was Philadelphia's marketplace with many great department stores, the upscale boutiques on Chestnut and Walnut Streets west of Broad Street made that area Philadelphia's most fashionable shopping district.

Once World War II ended, Rittenhouse Square was poised to change again, with plans for new apartment houses and office buildings to replace many of its remaining 19th-century houses. Despite the challenges of the Depression and World War II, Rittenhouse Square continued to provide a peaceful oasis at the heart of its rapidly changing neighborhood.

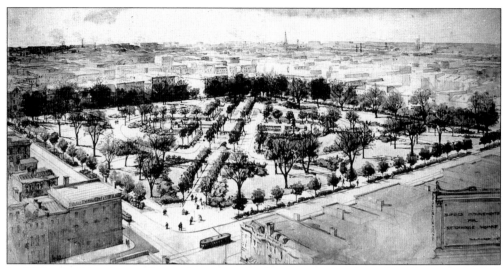

In 1913, the Rittenhouse Square Improvement Association was formed at the suggestion of Mrs. J. Willis Martin. They hired one of Philadelphia's premier architects, French-born Paul Philippe Cret, to design a new plan for the square. Cret's brilliant Beaux-Arts plan, based on the Parc Monceau in Paris, draws pedestrians in from the four corners of the square down tree-lined walks lined with benches toward the fountains, flower beds, and statuary near the center. Today the square is bordered with high-rise buildings, but still functions as one of Philadelphia's best urban city parks, a tribute to Paul Philippe Cret's visionary design. (Free Library of Philadelphia.)

Since 1914, Rittenhouse Square has hosted an annual spring flower market to raise funds for deserving charities, a tradition that continues today. On May 20, 1914, the Rittenhouse Square Improvement Association Flower Committee volunteers, above, had their picture taken as they sold flowers at the first flower market to help complete the renovation of the square, begun the year before. (Free Library of Philadelphia.)

The "elusive" Thomas Dolan (as he was called) was a moving force in Philadelphia at the dawn of the 20th century. Dolan lived in an elaborate mansion at 1809 Walnut Street, decorated by the famous Victorian interior designer George Herzog. Dolan gained monopolistic control of entire industries, from the manufacture of wool textiles to gas production, making him Philadelphia's fifth-richest person when he died in 1914. He was the president of the Quaker City Dye-Works Company, the Philadelphia Association of Manufacturers of Textile Fabrics, the Textile Dyers Association, vice president of both the National Association of Wool Manufacturers and the Union League Club, trustee of the Pennsylvania Museum of Industrial Art, and a director in numerous corporations. Below is the United Gas Improvement Gas Works at Twenty-second and Market Streets, part of one of the many cartels created by Dolan. (Free Library of Philadelphia.)

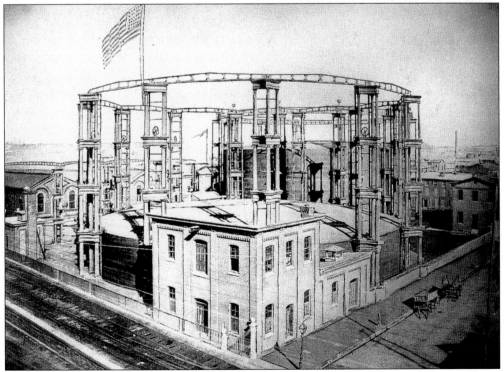

The Thomas Alexander Scott House at 1830 Rittenhouse Square was demolished in 1912 for Rittenhouse Square's first high-rise apartment house, seen here in an architect's rendering. The house's demolition contractor could not find anyone interested in buying or even carting away the Frank Furness–designed High Victorian interior woodwork and fireplaces that are so prized today. This new apartment house was an omen of things to come for the square as the lifestyles of the rich began to change, with many giving up their town houses for the convenience of apartment living. (Free Library of Philadelphia.)

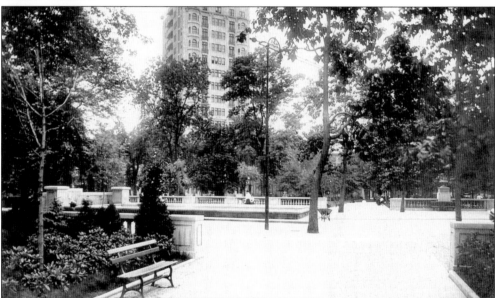

In 1912, Frederick Webber, a former partner in Milligan and Webber Architects who specialized in apartment houses, designed the square's first high-rise for Samuel Wetherill at 1839 Rittenhouse Square (seen here looking southwest across the square). When the Wetherill Apartments opened, even the servants' quarters had an unobstructed view of the newly renovated park. The building is now a condominium and still has its elaborate Beaux-Arts wrought iron and glass entrance canopy. (Free Library of Philadelphia.)

Billy by sculptor Albert Laessle has been a favorite of children since it was placed in Rittenhouse Square in 1914, a gift from Eli Kirk Price, Esq. By 1930, when this photograph was taken, the billy goat's horns had already been worn to a golden finish by the caresses of thousands of children. (Free Library of Philadelphia.)

In Rittenhouse Square's northeast diagonal walkway stands the Price Memorial Sundial, a sculpture of two playing children holding aloft a sundial in the form of a giant sunflower head. Philadelphia artist Beatrice Fenton created the sculpture as a memorial to Evelyn Taylor Price, who served as the president of the Rittenhouse Square Improvement Association and Rittenhouse Square Flower Market Committee. (Free Library of Philadelphia.)

RITTENHOUSE SQUARE ✦ Philadelphia

The Philadelphia Art Alliance published a series of postcards in 1926 featuring Philadelphia landmarks depicted by major graphic artists. Jessie Willcox Smith designed this postcard of children playing in the center of Rittenhouse Square. Just as in the 1920s, children still love the square and dogs still frolic in the fountain pool containing Paul Manship's sculpture of the *Duck Girl,* shown in the background of this postcard.

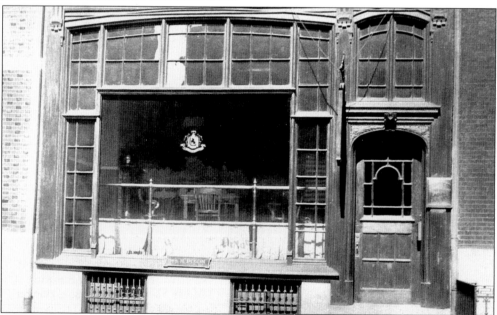

By 1914, fashionable shops, such as this custom dress shop on the ground floor of a once residential property, began to appear west of Broad Street as the commercial district moved west on both Walnut and Chestnut Streets. Designed by an unknown architect, this shop's facade shows an English arts and crafts influence. The shop had a discreet brass plate at the front door instead of the large commercial signage found on storefronts today.

Designed by architect Frederick Webber, the Vida Apartments at 235 South Fifteenth Street were built in 1920. Webber specialized in apartment and hotel design and was a favorite of developers in the first two decades of the 20th century. The Vida is still standing, now with a street-level restaurant, on the southeast corner of Fifteenth and Locust Streets next to the modern Academy House Apartments designed by Otto E. Reichard-Facilides and Associates in the late 1980s. (Free Library of Philadelphia.)

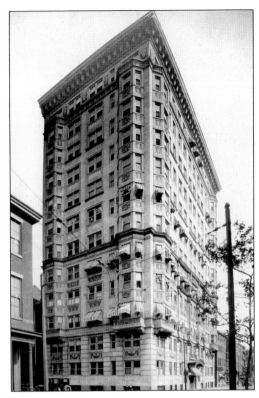

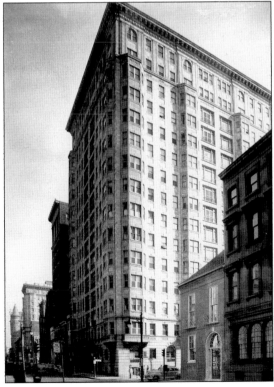

The Versailles Apartments at 1530–1534 Locust Street, built around 1920, was also designed by Frederick Webber. He used an ingenious plan for the Versailles, giving it two elevator cores and thus eliminating long corridors. The servants' quarters were originally located on the top floor of the building. The apartment house is still a luxury building today. (Free Library of Philadelphia.)

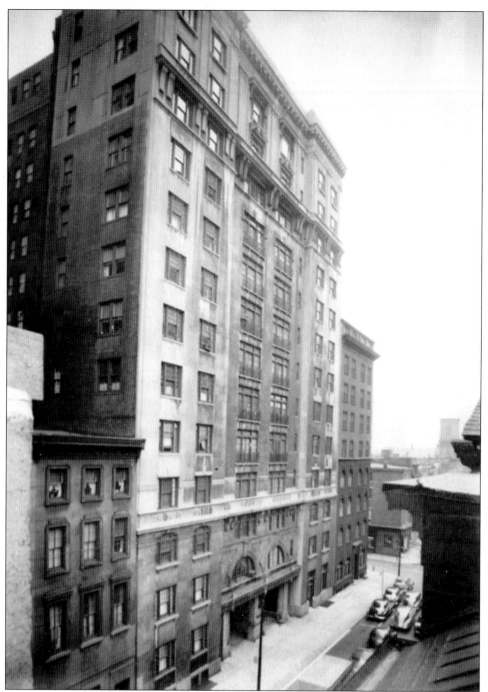

This is the Touraine Apartments as it looked in 1949. Built in 1917 as an elegant hotel and apartment house at 1520 Spruce Street, it was another high-rise designed by Frederick Webber. With the Touraine, Webber departed from his typical apartment design, which usually featured many bay windows, for a more modern design. In 1982, the development firm Landmarks for Living spent $16 million to restore and transform the building into luxury apartments. (Free Library of Philadelphia.)

Shown here is the Sugarman, Hess, and Berger architectural rendering of their proposed design for 1900 Rittenhouse Square. The art deco–style apartment house was built between 1923 and 1926 on the site of the Frank Lankenau mansion that was later owned by Thomas B. Wanamaker. It is now a condominium on the National Register of Historic Places. (Free Library of Philadelphia.)

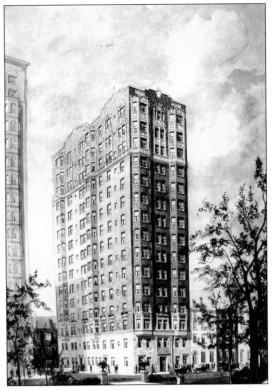

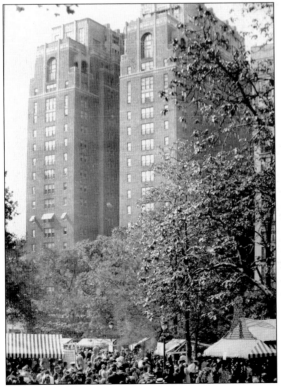

This view of the north side of Rittenhouse Square shows the Rittenhouse Plaza and Wellington Apartments. The Wellington (seen partially on the right) was originally built as a hotel in 1926. Located on the southeast corner of Nineteenth and Walnut Streets, the former site of cotton merchant John H. McFadden's townhouse, the Wellington was designed by architect Ralph Bowden Bencker. In 1924, architects McLanahan and Bencker designed the art deco Rittenhouse Plaza on the northwest corner of Nineteenth and Walnut Streets, on the site of the historic Physick-Roberts mansion. Bencker is best known for his highly decorative art deco designs for Horn and Hardart's Automat restaurants. (Free Library of Philadelphia.)

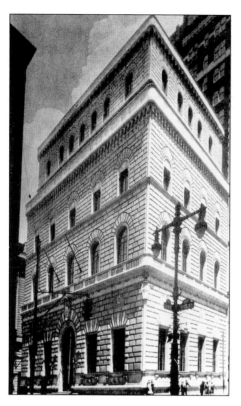

For the first part of the 20th century, the banking firm of Drexel and Company was managed by Philadelphia's outstanding financier, Edward T. Stotesbury, who became head of the company after the death of Anthony J. Drexel. In the Roaring Twenties, Drexel and Company built this great Italian Renaissance Palazzo on steroids, a symbol to its stockholders and clients of its strength and stability. Located at the northeast corner of Fifteenth and Walnut Streets, it was built in 1925–1927 and designed by architects Day and Klauder who gave the building an elegant banking floor, typical of the great bank buildings then being built in Philadelphia.

Flanking Drexel and Company's Fifteenth Street main entrance were two great lanterns made by the famous Samuel Yellin Iron Works of Philadelphia. Above the windows are bas-relief panels of the signs of the zodiac. In 1980, the building was used for commercial space, and as of the writing of this book, the ground floor has been severely remodeled into a Bally Total Fitness Center.

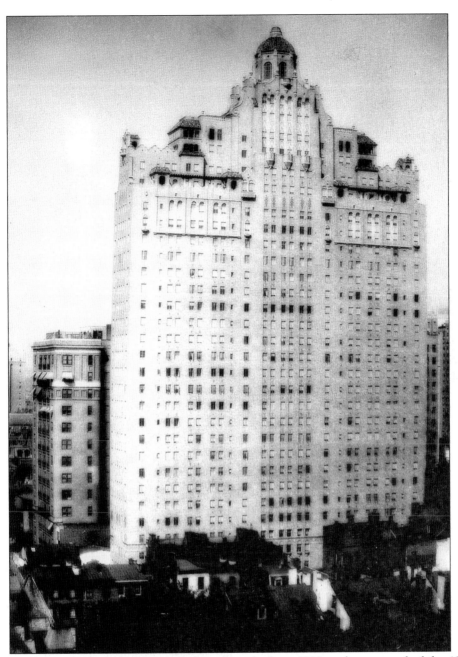

The Drake Hotel at 1512–1514 Spruce Street was built in 1929 at the very end of the 1920s building boom in Philadelphia. The architects were Ritter and Shay, who designed this romantic art deco/Spanish Baroque skyscraper. The 30-story Drake Hotel was one of the city's largest buildings when it was constructed. The brick-clad art deco building incorporates Spanish Baroque ornamentation, accented with sculpted terra-cotta decoration. Its strong silhouette with open terraces overlooking the city gives the building its distinctive profile and creates a unique appearance against the skyline. Originally built with 753 rooms for use as apartments and hotel lodging, this long narrow building has recently been renovated exclusively as apartments. (Free Library of Philadelphia.)

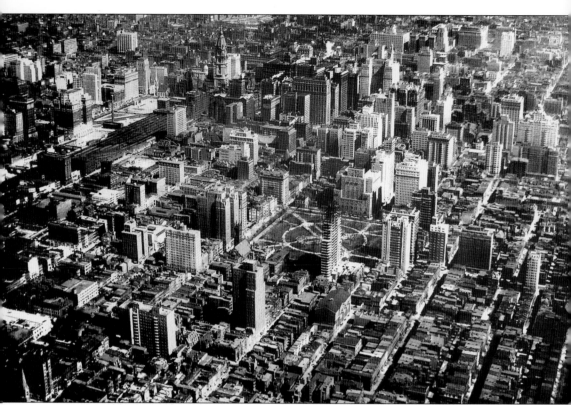

The Rittenhouse Square area looking east as photographed from an autogyro (helicopter) in 1929 shows how developed the perimeter of the square had become during the Roaring Twenties. The plan of the walkways through the square, laid out by architect Paul Philippe Cret in 1913, can be seen clearly in this winter photograph. The steel frame of the Chateau Crillon, designed by Horace Trumbauer, rises on the west side of the square, its steel structure soon to be covered by a Romanesque Northern Italian facade. All new skyscrapers built in the 1920s respected the height restriction of the unwritten "gentleman's agreement," which required them to be lower than the hat on the statue of William Penn atop the Philadelphia City Hall tower. (Free Library of Philadelphia.)

The 1800 and 2000 blocks of Delancey Place, seen here, remained among Philadelphia's premier residential streets from the 1920s through the 1940s. Most of these row houses were built in the 1860s in the Classical Revival style, although some were renovated in the Georgian Revival style in the early 20th century. The 2000 block of Delancey Place was home to the Rosenbach brothers (now a museum) and the late Sir Carpenter Batchelder (featured in the Eddie Murphy movie *Changing Places*). The Horace Jayne Mansion at 320 South Nineteenth Street, designed in 1895 by architect Frank Furness, can be seen at the end of the street. The 1700 and 1900 blocks of Delancey Place contained the stables and carriage houses for the grander houses. What makes Delancey Place unique is that it does not run in a straight line like most Philadelphia streets. Delancey Place is staggered to discourage through traffic, which may account for its longevity as a superb example of a well-preserved 19th century residential street.

Little did anyone suspect in 1936, when this photograph was made, that the shape of things to come for the Aldine Theater in 2008 was that it would become home to a chain drugstore. Located on the southeast corner of Nineteenth and Chestnut Streets, the Aldine Theater, designed by William Steele and Sons, opened in November 1921 as a prestigious theater that presented movie premieres. It had an elegant interior, a 20-piece orchestra and a major Moeller pipe organ that accompanied silent movies. Sadly, almost all of Philadelphia's great movie palaces from the 1920s were demolished or changed to other uses within a half-century of their construction. (Free Library of Philadelphia.)

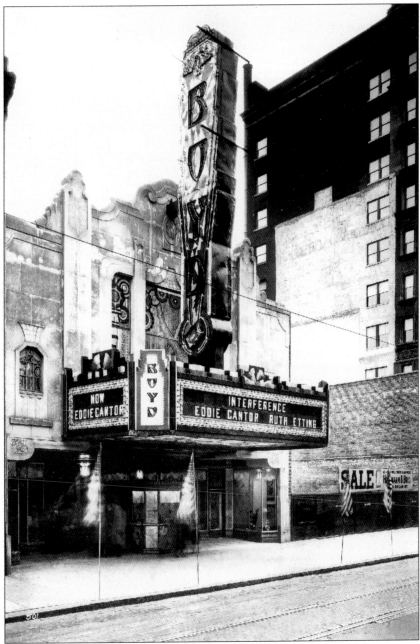

The Boyd Theatre at Nineteenth and Chestnut Streets is a French art deco masterpiece. It opened on Christmas 1928 as one of Philadelphia's most luxurious theaters. The angular vertical sign and marquee gave theatergoers a hint of what they would see upon entering the Boyd. The theater's architects, Hoffman-Henon, spared no expense on its interior furnishings, custom designing the crystal lighting, murals, and statues that graced the lobby and auditorium. In the 1980s, three smaller theaters were added next to the Boyd, and it was named Sameric I, II, and III. Since the Boyd Theatre closed in 2002, there has been a grassroots movement led by Howard Haas, Esq., president of Friends of the Boyd, to restore the theater's interior to its 1928 French art deco splendor. (Irving R. Glazer Collection of the Athenaeum of Philadelphia.)

In 1932, 28 years after the first Rittenhouse Square Flower Market, hemlines had dropped with the stock market crash, and a new generation of volunteers continued the tradition of selling flowers to benefit the square. Since 1914, the Rittenhouse Square Flower Market has raised funds for charities and the improvement and maintenance of the square. It is still an annual Rittenhouse Square tradition. (Free Library of Philadelphia.)

Even in the depths of the Depression, the square was packed with families wearing their Sunday best to enjoy the 1932 Rittenhouse Square Flower Market. (Free Library of Philadelphia.)

In 1933, Philadelphia attorney Maurice J. Speiser (1880–1948) hired architect George Howe to modernize his 19th century town house at 2005 Delancey Place. With William Lescaze, Howe had just finished the design for the PSFS Building at Twelfth and Market Streets, now a Loews Philadelphia Hotel. The PSFS Building is considered a modernist masterpiece, the first American skyscraper built in the International style. Howe designed the Speiser house in this new International style as well. It is doubtful if Howe could get approval from the Philadelphia Historical Commission today for this modern design in a historic district. The home's owner, Maurice J. Speiser, was a fascinating personality. He made regular trips to Europe in the 1920s, where he met with Hemingway and other modern writers. He and his wife Martha Glazer Speiser were patrons of the arts and friends to many noted writers, artists, and writers. Speiser assembled the most comprehensive collection of Hemingway's works, which is now at the University of South Carolina.

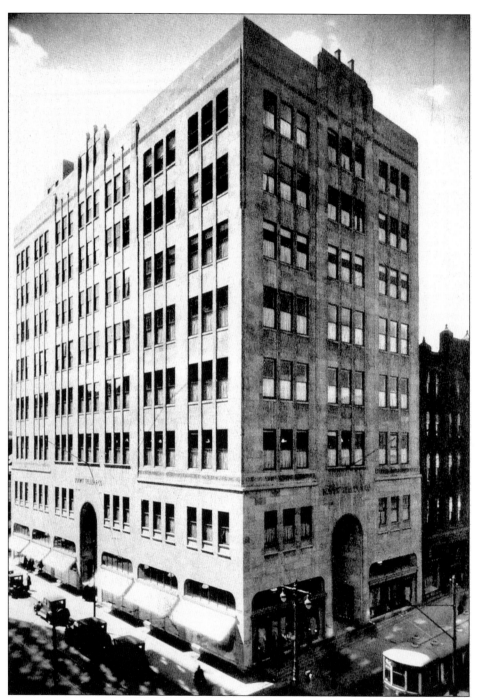

Built in 1927, the art deco–style Philadelphia store of Bonwit Teller at 1700 Chestnut Street was designed by architect Clarence Edmond Wunder. The store was one of the most elegant of the many upscale shops that lined Chestnut Street. Bonwit Teller, an exclusive ladies apparel store, was founded by Paul J. Bonwit, who in 1897, partnered with Edmund D. Teller to open their first Bonwit Teller store in New York City. Although no longer a Bonwit Teller, the building still stands and is used as a retail store. (Free Library of Philadelphia.)

Bonwit Teller's elegant window displays show the latest Paris and New York fashions in this 1939 window display, making Chestnut Street look like New York's Fifth Avenue. In addition to carrying custom-made pieces, Bonwit Teller also sold fashion designs by famous French coteries and American designers like Nettie Rosenstein. One would never guess Philadelphia was just coming out of the Depression from this extravagant window display. (Free Library of Philadelphia.)

Founded in 1824, Jacob Reed's Sons was originally located at 301–303 South Front Street in Society Hill. After several moves, the men's clothing store moved to an elegant Italianate structure at 1412–1414 Chestnut Street in 1896 (left). In October 1921, the building was transformed into the Karlton Theater.

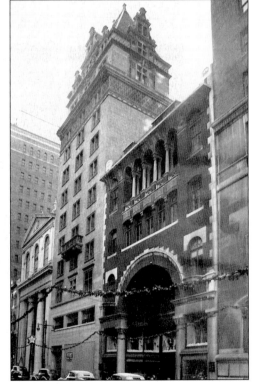

In 1905, Jacob Reed's Sons moved to 1424–1426 Chestnut Street, seen as it looked in 1949. Designed by Price and McLanahan in a Byzantine arts and crafts style and decorated with colorful Mercer tiles, the store's multicolored facade was blackened with soot by the late 1940s, as was much of Center City Philadelphia. It was one of the first reinforced concrete buildings built in Philadelphia. Jacob Reed's Sons was one of the finest men's stores in Philadelphia, a shop fondly remembered by Robert Morris Skaler where the longtime salesman, Mr. Petit, always knew his name. Unfortunately, after almost 160 years in business, Jacob Reed's Sons closed its doors in 1983.

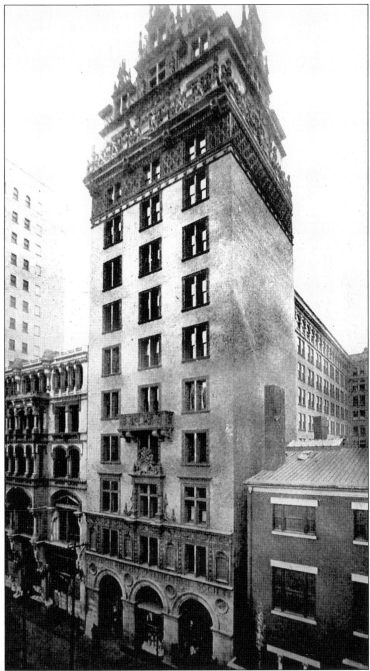

Built in 1899 at 1420 Chestnut Street, the Crozer Building (also known as the American Baptist Publishing Society) was designed by architects Frank Miles Day and Brother. This 1899 photograph shows the building's three arches at the street level, next to the future site of the Jacob Reed's Sons store. The Crozer Building's original street-level facade has been recently restored from the unsympathetic 1950s modernization (seen on page 102) to its elegant 1899 design. To the left of the Crozer Building was the 1887 C. F. Hazleton Building at 1416 Chestnut Street designed in an elaborate Queen Anne style by architect William Lockington.

In the 1940s, Market Street at the northern edge of the Rittenhouse Square area was lined with theaters. On the 1600 block of Market Street, seen above and below lit at night, were the Fox that seated over 2,400 and the Stanton that seated over 1,400. The Center Theater's marquee features Broderick Crawford in that now-forgotten 1942 movie *Butch Minds the Baby*. Unfortunately, the smaller Studio and Center theaters later became pornographic movie houses as the block deteriorated in the 1970s. Further west on Market Street were three immense theaters: the Stanley seating 2,900 at Nineteenth and Market Streets, the massive Mastbaum seating over 4,700 at Twentieth and Market Streets, and the Erlanger seating almost 1,900 at Twenty-first and Market Streets. These five major theaters were built in the golden age of movie palaces from 1914 to 1929. They have all been demolished, as Market Street West in the 21st century has been lined on both sides with high-rise office buildings. (Free Library of Philadelphia.)

Six

MODERN
RITTENHOUSE SQUARE
1950 TO THE PRESENT

After World War II, Rittenhouse Square faced many challenges, along with the rest of Philadelphia. As longtime residents joined the postwar flight to the suburbs, most of the remaining townhouses were replaced by high-rise buildings. Starting with the Rittenhouse Claridge and Savoy in 1950–1951, luxury apartment buildings began to appear around the square for the first time in decades. At the same time, the construction of new office buildings introduced commerce into the square's once-sacrosanct atmosphere.

Concerned over the deterioration of Rittenhouse Square and the surrounding area, a group of citizens formed the Center City Residents Association (CCRA) in 1946. The CCRA worked to improve the square by planting new trees and cleaning up the park. Starting in 1948, the CCRA erected a Christmas tree in the square and staged public Christmas carols. In 1950, the CCRA interceded when Rittenhouse Square's existence was threatened by an underground parking garage.

Despite the CCRA's efforts, Rittenhouse Square continued to suffer from overuse, neglect, and crime. During the late 1960s, the square was a favorite hangout for hippies, who staged love-ins and Vietnam War protests there. Within a few years, the "age of Aquarius" gave way to a harsher reality: a 1974 *New York Times* article described how nannies with children and dog-walking dowagers were chased from the square by "shuffling panhandlers, looking through scarred eyes for their first mark of the day." In response, the Friends of Rittenhouse Square was established in 1976. Each year, the Friends raise thousands of dollars to maintain and landscape the square with their annual ball and other activities.

In the 1980s, a rising real estate market made Rittenhouse Square Philadelphia's hottest residential neighborhood. To protect the historic area from overdevelopment, the Rittenhouse Fitler Historic District was established in 1995. The irregularly shaped district, stretching from Fifteenth to Twenty-fifth Streets and from Ludlow Street to Addison Street, encompasses Rittenhouse and Fitler Squares, and many of the surrounding streets lined with beautiful 19th- and early 20th-century residences.

Despite the restrictions of the historic district, the recent real estate bubble has quickened the pace of construction on and around the square. As of 2007, several older structures (including the former Penn Athletic Club and the Barclay and Warwick Hotels) had been or were being converted to luxury condominiums. Meanwhile, two new condominium towers are rising at opposite ends of the square along Walnut Street. While Rittenhouse Square continues to attract the city's affluent and stylish, many Philadelphians fear the impact of rampant development on what Jane Jacobs once called "the perfect urban neighborhood."

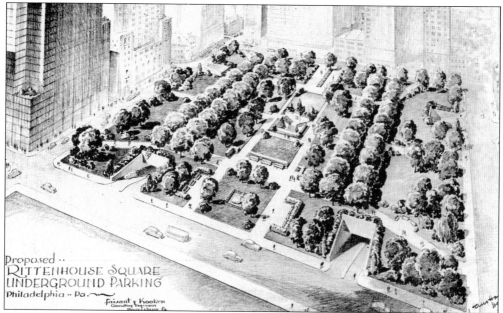

In 1950, Underground Garages, Inc., proposed building a parking lot under Rittenhouse Square, the architect's sketch for which is seen above (looking south across Walnut Street). The garage would have obliterated Paul Cret's 1913 design and resulted in the loss of many old-growth trees. Widespread opposition to the subterranean garage by numerous community groups and individuals led to the dropping of the plan. (Temple University Libraries, Urban Archives, Philadelphia.)

In response to Rittenhouse Square's worsening condition, local residents and businesses formed the CCRA in 1947. Besides opposing the underground garage scheme, CCRA raised funds for square maintenance by sponsoring holiday celebrations, house tours, and galas. Shown above is the display for one of CCRA's Easter celebrations in Rittenhouse Square from the early 1950s. (Free Library of Philadelphia.)

106

In 1950, the Rittenhouse Claridge was built at the southeast corner of Eighteenth and Walnut Streets, on the site of the William Weightman mansion (demolished in 1929). The Claridge, a 25-story luxury apartment building, was built at the same time as the Rittenhouse Savoy on the south side of the square. The Claridge and Savoy represented the first high-rise construction in Center City since the 1920s. (Free Library of Philadelphia.)

On September 21, 1953, Bailey Banks and Biddle, a Philadelphia institution since 1832, moved to a modern store at 1530 Chestnut Street (the opening day party is shown here). Here the firm sold the finest jewelry, china, and silver and crafted Purple Heart medals for the U.S. Army. Bailey Banks and Biddle closed its Philadelphia store in 2002, a victim of changing retail and residential patterns. (Free Library of Philadelphia.)

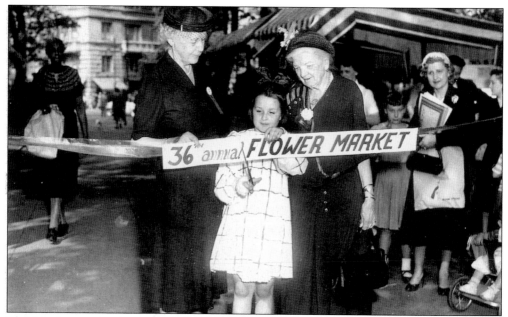

Despite changes in the surrounding neighborhood, traditions like the annual Rittenhouse Square Flower Market continued. The 36th annual flower market in 1953 honored Mrs. Charles Worts, a member of the original Rittenhouse Square Flower Market Committee in 1917. Shown from left to right are Mrs. Charles Starr, chairperson of the 1953 Flower Market; Alice Dayton, Miss Flower Market of 1953; and Mrs. Worts. (Free Library of Philadelphia.)

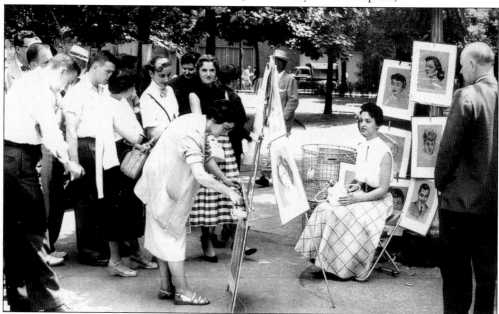

A photograph from the innocent 1950s shows neatly dressed students watching a local artist draw charcoal portraits during the 1954 Annual Summer Art Show in Rittenhouse Square. Many amateur and professional artists got the opportunity to show their work at what was nicknamed the "Clothesline" art exhibit. This well-attended art show continues to be held in the square every year. (Free Library of Philadelphia.)

Christmas celebrations sponsored by the CCRA became a highlight in Rittenhouse Square during the 1950s, complete with a Christmas tree lighting, carol singing, and other festivities. In this December 1952 photograph, carolers in Victorian costumes sing from atop a tally-ho carriage at the corner of Twentieth and Spruce Streets. Seated next to the driver in the front is Mrs. John F. Wilson of the Rittenhouse Square Decoration Committee. Today local volunteers continue to decorate the square beautifully for the holiday season. (Temple University Libraries, Urban Archives, Philadelphia.)

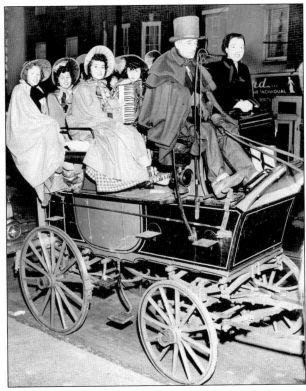

In 1952, Philadelphia artist and architect Alfred Bendiner painted a mural of Rittenhouse Square as it appeared in 1866 for the local branch of the Fidelity-Philadelphia Trust Company. Two young residents, Caroline T. Pennypacker and Jean Carver, inspect a section of Bendiner's work showing an open carriage proceeding past a stylized Church of the Holy Trinity. (Temple University Libraries, Urban Archives, Philadelphia.)

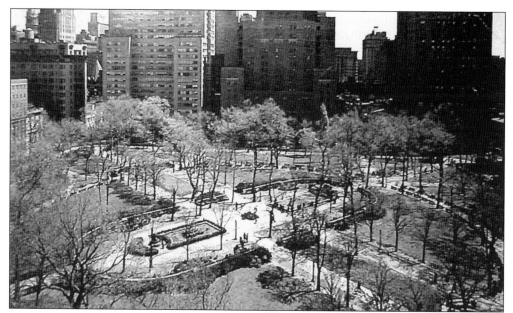

Here is Rittenhouse Square around 1960, as viewed from the newly built 25-story luxury apartment building, 220 West Rittenhouse Square, looking east. While new structures continued to rise on and around the square throughout the 1960s and 1970s, many residents remember the era as a low point in the square's history, when it was dirty, poorly maintained, and unsafe at night. (Andrew Herman.)

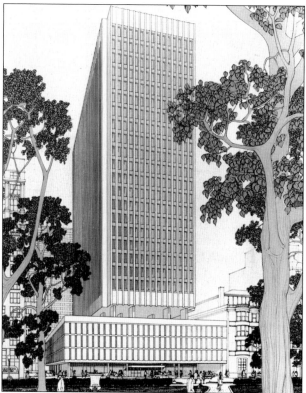

In 1967, construction began on the Mutual Benefit Life Building at 1845 Walnut Street. The 20-story modern structure, designed by architects Eggers and Higgins, Nowicki and Polillo, also included a 570-car garage. The intrusion of this high-rise office building into the once-residential heart of Rittenhouse Square indicated the spread of the Center City business district up Walnut Street. (Temple University Libraries, Urban Archives, Philadelphia.)

During the 1960s, Rittenhouse Square became a favorite hangout first for beatniks, and then for hippies. This 1969 photograph shows *Easy Rider* star Peter Fonda (center) talking with, from left to right, William Oliver, Bonnie Schultz, and Susan Strayer. In 1967, three hippies brought suit against the Philadelphia police and Fairmount Park guards, seeking to stop mass arrests and saying they were "harassed for unconventional appearance and manner and life style." The following year, a federal judge upheld young people's right to congregate in Rittenhouse Square, saying "It is not a crime to be a hippie." (Temple University Libraries, Urban Archives, Philadelphia.)

Despite social upheavals, the Easter parade continued to be a beloved tradition in Rittenhouse Square throughout the 1960s. An outgrowth of the post-church promenade taken by wealthy residents in the 1800s, the Easter parade became a fashion contest sponsored by CCRA after World War II. Shown here are the "best-dressed" winners for 1968, showing off their prize ribbons and new outfits as they perch precariously on a raised platform. (Free Library of Philadelphia.)

In 1960, several 19th-century brownstones were demolished at the southwest corner of Rittenhouse Square. On the site rose the Rittenhouse Dorchester Apartments, a 32-floor concrete frame building with curtain wall windows designed by Milton Schwartz and Associates. The L-shaped building wrapped around the neighboring Rittenhouse 222 Apartments, designed by Horace Trumbauer as the Chateau Crillon in 1928. The luxury Dorchester Apartments opened its doors to residents in 1964. (Temple University Libraries, Urban Archives, Philadelphia.)

No scandal better epitomized Rittenhouse Square's dubious status during this period than the 1975 murder of Knight Ridder newspapers heir John S. Knight III in his 23rd-floor, $1,050-a-month apartment at the Rittenhouse Dorchester. The 30-year-old Knight was bound and stabbed during a home invasion led by Felix Melendez, who procured gay prostitutes for the bisexual newspaper heir. Melendez was subsequently killed by his fellow robbers, Salvatore Soli and Steven Maleno, who were later sentenced to life imprisonment for the deaths of Knight and Melendez. (Free Library of Philadelphia.)

Throughout changing times, many businesses on and around Rittenhouse Square continued to serve their customers faithfully. From 1959 to 1982, the area had a real old-time neighborhood pharmacist in Milton "Doc" Lebby, owner of Lebby Apothecary. His store, complete with two large glass jars filled with colored water in the front window, was first located at the northwest corner of Eighteenth and Sansom Streets but later moved to 104 South Eighteenth Street. Because of Lebby's expertise in compounding drugs and making medications from scratch, many doctors, hospitals, and other pharmacists directed their patients to his attention. Doc Lebby and his wife Sarah knew their customers by name, delivered prescriptions to their homes, and sometimes opened their store late at night to fill emergency prescriptions for sick patients. Doc Lebby also refused to sell cigarettes, knowing that they were bad for his customers' health. He preferred to take the loss and run a high-class store, carrying Kent English hairbrushes instead. (Sarah Lebby.)

One of Rittenhouse Square's most dazzling postwar residents was Henry Plumer McIlhenny, a connoisseur of art and antiques, world traveler, socialite, philanthropist, and chairman of the Philadelphia Museum of Art. Independently wealthy, McIlhenny amassed an art collection that included masterpieces by Renoir, Van Gogh, Degas, and Toulouse-Lautrec. Seen here in a promotional photograph for the 108th Academy of Music Concert and Ball program in 1965, McIlhenny was called "the only person in Philadelphia with glamour" by Andy Warhol. His legendary parties, at both his Rittenhouse Square residence and his castle in Ireland, were attended by Jackie Onassis, Queen Elizabeth II, Rudolf Nureyev, and Greta Garbo.

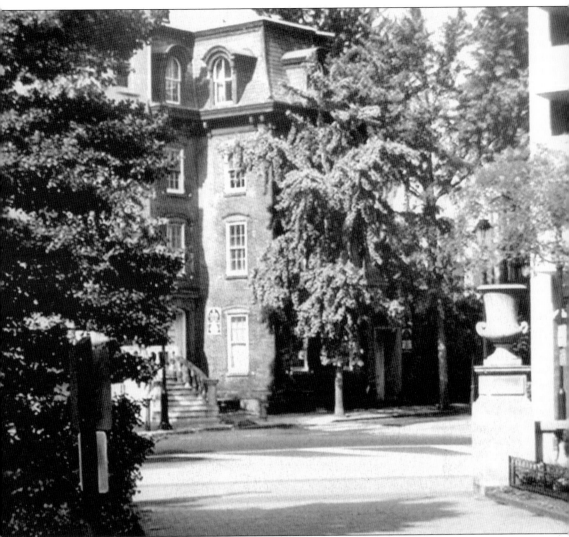

To house his fine collections of art and antiques, McIlhenny purchased four 19th-century town houses at the southwest corner of Rittenhouse Square in the late 1940s. McIlhenny combined the houses into a 35-room, 17,000-square-foot mansion, adding a double-doored rotunda as a main entrance. For many Philadelphians, an invitation to this bijou residence was the ultimate social status symbol. After McIlhenny's death in 1986 at the age of 75, much of his collection was willed to the Philadelphia Museum of Art while the rest was sold at auction. His former residence at 1912–1916 Rittenhouse Square has passed through several owners, and stands empty at the time of this book's writing.

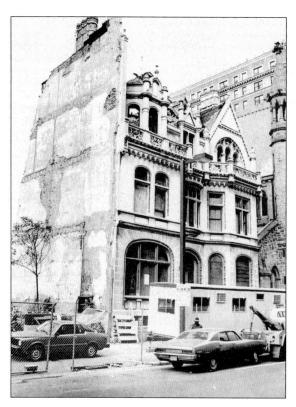

The fate of the historic Scott-Wanamaker House at 2032 Walnut Street symbolized the changing fortunes of the Rittenhouse Square area. Built in 1883 by Theophilus P. Chandler for sugar magnate John P. Scott, the house was occupied by department store owner John Wanamaker from 1894 until his death in 1922. During the Depression, it was converted into apartments. After being damaged by a fire in 1978, the house was scheduled to be torn down and replaced by an apartment tower. This photograph shows the house during its 1981 demolition. (Temple University Libraries, Urban Archives, Philadelphia.)

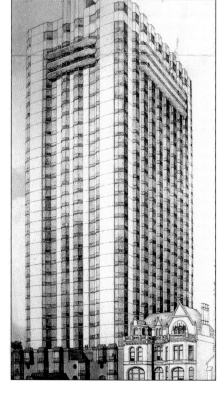

Thanks to the involvement of community activists, the facade of the Theophilus P. Chandler house was preserved while the rest of the structure was replaced by a modern 32-floor apartment building at 2018–2032 Walnut Street designed by Otto Spier and Hugh MacCauley. Today the Wanamaker House is a 333-unit luxury condominium. (Free Library of Philadelphia.)

Numerous art galleries and antique stores on Chestnut and Walnut Streets continue to cater to Rittenhouse Square's well-off residents. Prominent among them is the Schwarz Gallery at 1806 Chestnut Street, which relocated from Atlantic City during the 1940s. Following the move, Frank Schwarz (seen above around 1980) and his wife Marie made Philadelphia artists and paintings the gallery's specialty. (Schwarz Gallery.)

The Schwarz family pet stands guard over priceless antiques on a sunny afternoon in the 1980s. In the background, the ornate entrance to the 1902 Belgravia Hotel is visible. After Frank Schwarz's death, his son Robert ran the gallery with his mother, while also serving as curator of the Stephen Girard Collection from 1970 to 1980. Today the Schwarz family continues to run the gallery, focusing on 19th-century American art, especially from the Philadelphia region. (Schwarz Gallery.)

Located at 210–218 South Nineteenth Street on the west side of the square, the Rittenhouse Hotel (at far right) opened in 1989 after a 15-year gestation. First conceived in the 1960s as the Carlyle, construction ceased for six years due to financial problems after the foundation was laid in 1974. In 1980, construction resumed, and a 33-story white "horizontal ziggurat" designed by Don Reiff was constructed. Legal and financial problems forced another halt in construction from 1983 to 1988. Finally the Rittenhouse Hotel opened for business as a luxury hotel and condominium tower in 1989, 15 years after its groundbreaking. (Robert Morris Skaler.)

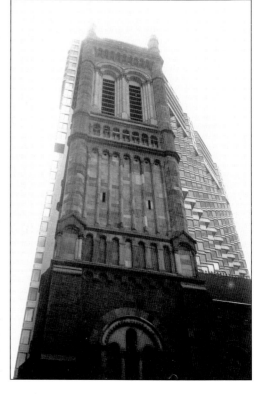

One of the buildings demolished for the Rittenhouse Hotel was the former Rogers-Cassatt residence at 202 South Nineteenth Street, located next to the Church of the Holy Trinity and used as the Episcopal Church House. When the 33-story hotel was completed, it blocked sunlight on the south side of the church. In 1989, the Rittenhouse Hotel owners installed several dozen floodlights on their north side so that the stained-glass windows on the church's south side are perpetually illuminated. (Church of the Holy Trinity.)

Today the Rittenhouse Hotel is one of Philadelphia's foremost hotels, winning the AAA Five-Diamond Award from 1991 through 2007. Its circular driveway (shown above) is graced by a statue and fountain titled *Welcome* by Evangelos Frudakis. The hotel is decorated with works of art by other Philadelphia artists, including Mary Cassatt, Joe Barker, Michael Webb, and Dan Cavaliere. (Rittenhouse Hotel.)

The Rittenhouse Hotel is a favorite of visiting celebrities, attracted by the Mary Cassatt Tea Room and Garden (seen at left), Lacroix at the Rittenhouse, Boathouse Row Bar, Smith and Wollensky, and the Adolf Biecker Spa and Salon. Along with Oprah Winfrey, Billy Joel, and the late Luciano Pavarotti, the hotel played host to Denzel Washington and Tom Hanks during the filming of Jonathan Demme's *Philadelphia*, and to Bruce Willis during *Twelve Monkeys*, *Sixth Sense*, and *Unbreakable*. (Rittenhouse Hotel.)

As real estate values soared around Rittenhouse Square in the 1980s and 1990s, many older hotels and buildings were renovated as condominiums. The "placidly patrician" Barclay Hotel at 237 South Eighteenth Street was once home to Philadelphia Orchestra leader Eugene Ormandy and Drexel, Morgan banker Edward T. Stotesbury. By the 1980s, it was best known as the site of Abscam, the infamous FBI sting operation of local politicians. In 1992, the building's owner filed for bankruptcy. In recent years, the Barclay has been reborn as luxury condominiums. Its ground floor restaurant, Barclay Prime, is famous for its $100 Philly cheesesteak made with Kobe beef.

The elegant Rittenhouse Plaza at Nineteenth and Walnut Streets has also been reborn in the wave of the real estate boom. One of the square's most elegant buildings when it opened in 1925–1926, the cooperative apartment house reverted to rentals during the Depression and was almost sold to the State of Pennsylvania as an office building in 1950. A 1980 renovation restored the lobby to its art deco glamour, complete with reproductions of the original lighting fixtures, Persian carpets, and period furniture from the Locust Street Theatre. Today the Rittenhouse Plaza, where a penthouse apartment carries a price tag of nearly $3 million, is undergoing further restoration.

The Warwick Hotel opened in 1926 at 1701 Locust Street, on the site of Harrison Row. It had 545 rooms and was designed by the architectural firm of Hahn and Balinson. The venerable English Renaissance–style structure is now listed on the National Register of Historic Places. In 2007, the 302-room hotel was fully renovated and is now the Radisson Plaza–Warwick Hotel. The bottom twelve floors are hotel rooms, while the top stories house luxury condominiums. (Radisson Plaza–Warwick Hotel.)

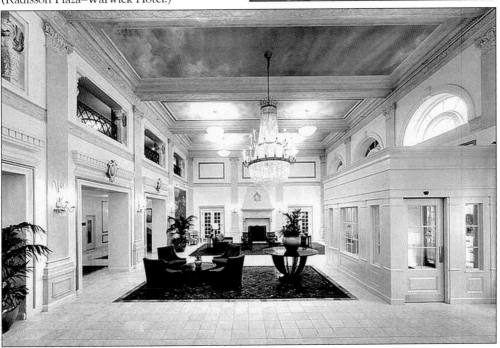

A fixture on Rittenhouse Square since the 1920s, the Curtis Institute of Music is today considered one of the foremost music schools in the world. Thirty percent of all positions among the top five American orchestras are held by Curtis alumni. In October 2004, the institute threw a festival in Rittenhouse Square to celebrate its 80th anniversary. Above, Philadelphia Orchestra bass trombonist Blair Bollinger conducts the institute's Brass and Percussion Ensemble. Below, flutist Bianca Rose Garcia, a 2006 Curtis graduate, demonstrates percussion instruments for future musicians at the Family Concert Table. (Curtis Institute of Music.)

The original version of this ornate Victorian guardhouse once stood at the Twenty-fifth and Green Streets entrance to Fairmount Park, and then in the middle of the Benjamin Franklin Parkway. In the 1980s, it was discovered abandoned, sitting in the mud, in Fairmount Park by Gersil Kay, Philadelphia Victorian Society board member and longtime Rittenhouse Square resident. She was instrumental in raising funds to restore the guardhouse and move it to the center of Rittenhouse Square. In 1997, the guardhouse was reconstructed through the generosity of the Friends of Rittenhouse Square and the Philadelphia Chapter of the Victorian Society in America. Architects Campbell Thomas and Company worked with Oak Leaf Conservatories of York, England, who fabricated the structure in England, then shipped it to Philadelphia in sections that were assembled in the center of the square. The new guardhouse functions as a headquarters for local security in and around Rittenhouse Square. (Campbell Thomas and Company.)

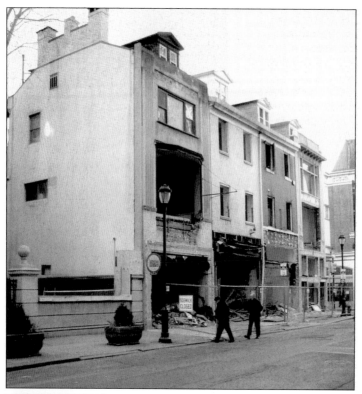

As development pressures increase on and around Rittenhouse Square, many older buildings are disappearing, such as Rindelaub's Row. Named for the popular Rindelaub's Bakery, the row of houses seen partially demolished was built around 1850 and stood on the west side of South Eighteenth Street, south of Sansom Street. Despite local protests, they were demolished in early 2007 (below) for the construction of Ten Rittenhouse, the first high-rise condominium built on Rittenhouse Square since the 1980s. (Below, L. M. Arrigale.)

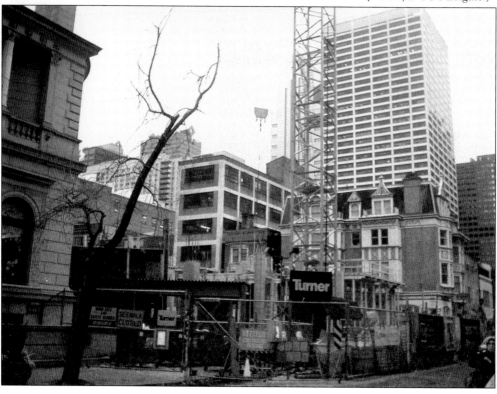

An architect's rendering of Ten Rittenhouse is seen looking northeast from Rittenhouse Square. The 140-luxury condominium was developed by A. R. C. Wheeler and designed by world-renowned architect Robert A. M. Stern, and is scheduled for completion in 2008–2009. Stern's design for Ten Rittenhouse attempts to compliment the character of the square's earlier architecture such as the nearby 1924 Alison Building. (Robert A. M. Stern.)

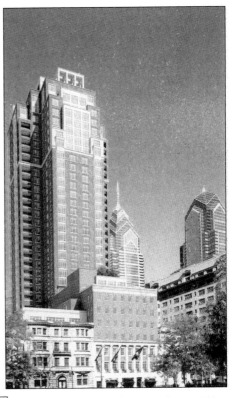

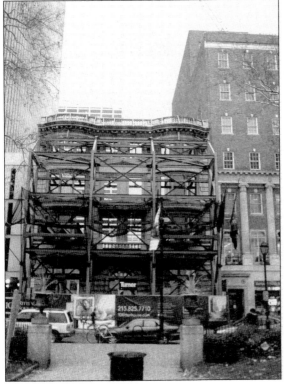

The once-grand Rittenhouse Club on Walnut Street stands gutted and demolished, with only its facade remaining, another victim of the demolition for Ten Rittenhouse. Upon completion of Ten Rittenhouse, the Rittenhouse Club facade will serve as the entrance to a Barney's Co-op. The Rittenhouse Club's neighbors, the Alison Building, and the Fell–Van Rensselaer mansion will also be incorporated into the design for Ten Rittenhouse but will remain intact. (L. M. Arrigale.)

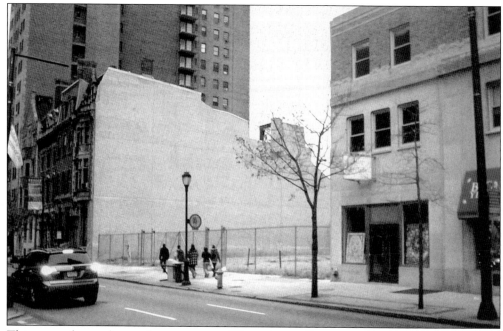

This empty lot at the northwest corner of Rittenhouse Square was once the site of the Eric Rittenhouse movie theater, torn down in 1994 after being damaged by a fire that swept the neighboring townhouse at 1913 Walnut Street. After remaining vacant for over a decade, plans were announced in 2007 for a new complex on the site. (L. M. Arrigale.)

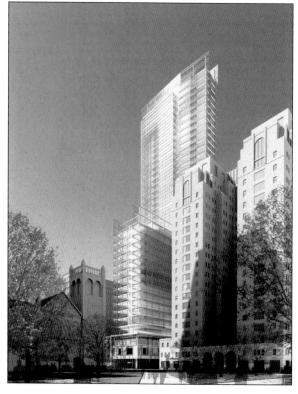

Designed by Bradford Fiske of KlingStubbins, the proposed design for 1900 Walnut Street consists of a 525-foot-tall condominium tower, a luxury hotel, and an extensive retail complex on the ground floor. On the eastern edge of the property, a 40-foot-wide park will provide pedestrian access between Walnut and Sansom Streets. The 575,000-square-foot development will be sheathed in a skin of clear, colored, and silk-screened glass, punctuated by verdigris copper bars, external solar screens, and perforated panels. (KlingStubbins.)

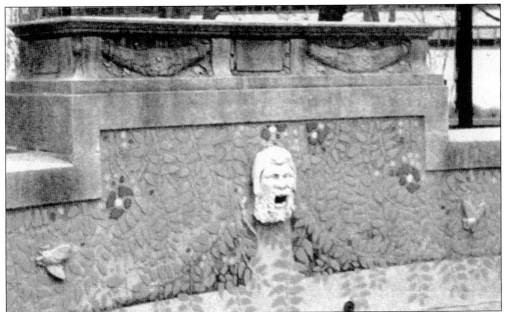

In 2000, the Friends of Rittenhouse Square spent $140,000 to restore the tile mural in the head wall of the fountain in the center of the square. The fountainhead represents Neptune, in a garden of seaweed, surrounded by salamanders, snails, and turtles. An integral part of the fountain when it was installed in 1913–1914, the mural was torn out during World War I. (L. M. Arrigale.)

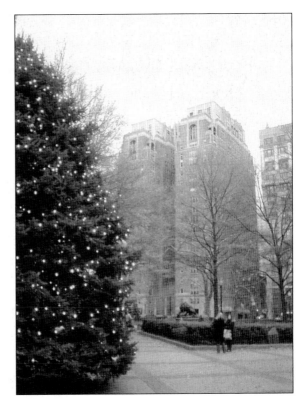

Christmas 2007 in Rittenhouse Square was marked by a mixture of the old and the new. Holiday shoppers admire the square's latest Christmas tree, festooned with lights and homemade decorations. In the background stands the Barye lion, a Rittenhouse Square fixture since 1894, and the 1924 Rittenhouse Plaza, currently undergoing renovation. (L. M. Arrigale.)

ACROSS AMERICA, PEOPLE ARE DISCOVERING SOMETHING WONDERFUL. *THEIR HERITAGE.*

Arcadia Publishing is the leading local history publisher in the United States. With more than 3,000 titles in print and hundreds of new titles released every year, Arcadia has extensive specialized experience chronicling the history of communities and celebrating America's hidden stories, bringing to life the people, places, and events from the past. To discover the history of other communities across the nation, please visit:

www.arcadiapublishing.com

Customized search tools allow you to find regional history books about the town where you grew up, the cities where your friends and family live, the town where your parents met, or even that retirement spot you've been dreaming about.